The Book of the Dead Bunny

The Book of the Begotten

A Book of the Origin and the First Bunny Spillage

Book 1

Guided and influenced by the spirit of the Great Dead Bunny
Transcribed by the Grandmaster of the Order of the Unrequited Dead Bunnies

The Books of the Dead is the first in series of e-Artists Books authored by Stephan Erasmus (the Grand Master of the Order of the Unrequited Dead Bunnies), edited by Johan Myburg and released in association with the Dead Bunny Society.

The book uses the aspects of religion and occultism in creating a mythology surrounding the Great Dead Bunny, the supposed deity that lead to the formation of the Dead Bunny Society in Johannesburg, South Africa in 2014. The Dead Bunny Society is a group of four artists that started the Society as an alternative platform for the promotion of the arts.

~2016~

Copyright © 2016 by M.S. Erasmus

All rights reserved. No part of this publication may be reproduced, distributed, or transmitted in any form or by any means, including photocopying, recording, or other electronic or mechanical methods, without the prior written permission of the publisher, except in the case of brief quotations embodied in critical reviews and

certain other non-commercial uses permitted by copyright law.

CONTENTS

1. BEFORE THE PRELUDE ... 11
 1. HOW IT ALL BEGAN .. 11
 2. MISCHIEF OF THE CELLS .. 13
 4. THE SECRET DEVIATION .. 18
 5. FINAL PREPARATIONS AND THE ARGUMENT 18
 6. AFTER THE FRUIT ... 23

2. THE PRELUDE .. 25
 1. A REST ... 25
 2. THE REAL BEGINNING .. 25
 3. HIS BELOVED ... 26
 4. MEETING BEFORE WINTER SLEEPY 33
 5. IN THE DARKNESS ... 35
 6. THE PILLOW QUESTIONING ... 37
 7. SUMMER AWAKENING AND
 THE START OF THE UNBEKNOWNST 48
 8. THE UNBEKNOWNST REARS ITS HEAD 53
 10. THE GROWING OF THE UNKNOWN 57
 11. THE ARRIVAL .. 58

3. BEGETTING AND THE BEGOTTEN 63
 1. THE FIRST TWO AND THOSE THAT FOLLOWED 63
 2. THE NEW RECORD KEEPING .. 78
 3. THE NEW CHALLENGE ... 83
 4. THE NEW CHALLENGE AGAIN ... 85
 5. THE NEW DREAM .. 86
 6. AFTER THE DREAM REVEALED AND
 THE CHALLENGE ... 93
 7. CHOOSING OF A NEW LEADER .. 96
 9. ON THE PLAIN ... 100
 10. OUTSIDE THE PLAIN .. 103
 11. BACK ON THE PLAIN .. 105

Book of the Dead Bunny
Book of the Begotten

1. BEFORE THE PRELUDE

1. HOW IT ALL BEGAN

1. In the beginning there was nothing but the glimmer of a potential moment.
2. The glimmer became stronger and stronger until the moment was waiting in noting.
3. Once the moment was, the vibration of the words spread through the emptiness like a voice shouting through the quiet of a silent night.
4. The one that spoke the moment in to being was the one true bunny, the bunny that is was and will die and be alive dead.
5. The word vibrated and made the moment fall apart into little spectacles of things that could not be contained in just one moment.
6. The moment exploded into an openness and the dust that fills it like dust would fill an empty house left alone for a very, very long time. And when you shake the fabric that covers the furniture it throws up a cloud of dust.
7. As time passed and space changed and before too much time passed it happened.
8. Several billion points of Onement was formed and it gravitated several more specs of dust to itself.
9. And more specs of dust gathered.
10. And more specs of dust gathered.
11. And more specs of dust gathered.
12. And more specs of dust gathered.
13. And more specs of dust gathered.
14. And more specs of dust gathered.
15. And more specs of dust gathered.
16. And more specs of dust gathered.
17. And more specs of dust gathered.
18. And more specs of dust gathered.
19. And more specs of dust gathered.
20. And more specs of dust gathered.
21. And more specs of dust gathered.
22. And more specs of dust gathered.
23. And more specs of dust gathered.
24. And more specs of dust gathered.

Book of the Dead Bunny
Book of the Begotten

25. And more specs of dust gathered.
26. And more specs of dust gathered.
27. And more specs of dust gathered.
28. And more specs of dust gathered.
29. And more specs of dust gathered.
30. And so it carried on for some time.
31. Until several billion clumps of dust was there and it grew bigger.
32. And bigger.
33. And bigger.
34. And bigger.
35. And bigger.
36. And bigger.
37. And bigger.
38. And bigger.
39. And bigger.
40. And bigger.
41. And bigger.
42. And bigger.
43. And bigger.
44. And bigger.
45. And bigger.
46. And bigger.
47. And bigger.
48. And bigger.
49. And bigger.
50. And bigger.
51. And bigger.
52. And bigger.
53. Until it was various sizes of average spherical heavenly bodies.
54. And they all looked quite nice.
55. And the one that have spoken the word decided to speak another word because things were going rather well.
56. And the word vibrated through everything including the heavenly bodies.
57. Things changed for all the bodies but we will continue with only one heavenly body that will matter to us as this body was one that is our own.
58. The vibrations started getting the body, we call home moist with sweat as it took a lot of hard work to start the great work.
59. And the vibrations shock things around and started doing things waking up movements and tensions.
60. Things started happening.
61. Firstly, there was an explosion not too far away and the explosion continued to spread harmful pockets of energy from its centre.
62. The harmful pockets of energy did things to the heavenly body that was painful but must be done.
63. Secondly, the pockets of

Book of the Dead Bunny
Book of the Begotten

energy started to mesh mash the dust and made them into things. And the things mostly separated and sometimes when the vibrations were good, things started to join.
64. Thirdly, when the vibrations were right the vibrations caused cells to develop and the cells started to do things and found that working together would be good.
65. And the cells created gangs.

2. MISCHIEF OF THE CELLS

1. When the gangs were formed, they started doing more things.
2. The first was the overreaching.
3. The cells started growing into something never before known or seen as there was only one pair of eyes around.
4. They grew into fractals, the fractals of the green.
5. And they grew but they did not grow as the one who spoke intended.
6. The Great Bunny spoke different words and the vibrations changed.
7. And everything changed.
8. Several times, things changed until the words he spoke were right.
9. And when the words were right the vibrations started working better.
10. So things mulled around as time was not yet important.
11. And through the event the living one, the one to die, laid down the foundations of the plain, also to be known as the warren.
12. Fourthly, the cells started living in the water and they were guided into being clever.

Book of the Dead Bunny
Book of the Begotten

13. Fifthly, the great one guided the very, very clever ones onto the land and into the air. These things were all guided and managed.

14. Sixthly, the great one whispered into the ear of a thingy on the land, something so terrible that it will never be repeated. It was the secret of the great one's death.

15. After this the Great Bunny was so tired that he decided that the things growing on and inside the heavenly body could just carry on without him.

16. It was a lot of hard work to get the heavenly body into a state of ecstasy to spew forth all these things.

17. He was happy with the sweat of his labours and decided to sit back, watch his embryo get to where it needs to be.

18. He felt that he has reached a sense of accomplishment.

3. PREPARATIONS OF THE SPECIAL PLACE

1. In the time that had passed a lot of things happened and changed.

2. A lot was left by the wayside of change.

3. The Great Bunny thought this was funny.

4. He knew how these things would create a lot of misunderstanding and confusion amongst the things that were now on his heavenly body.

5. He giggled to himself for a bit.

6. After his giggles died down the Great Bunny sat on his haunches and started to reflect and consider the path he had chosen not only for himself but for the rest of everything.

7. He considered the path, the route of the path and the road he would cross.

8. He considered the moment of the crossing.

9. He was quiet.

Book of the Dead Bunny
Book of the Begotten

10. After the lapsing of time onto itself he decided that thinking too much at this point in time will not be beneficial to his plan.
11. He carried on with what must be done. So he started another part of the great work.
12. He thought of himself as an artist – not just any artist but an agricultural artist sculpting a special place, the special place where it all would start.
13. He slowed down the pace of continual change as he was working diligently.
14. His toolbox opens on one side with tools specially designed for his work.
15. He would reach into his Toolbox and a very big spade came forth.

Book of the Dead Bunny
Book of the Begotten

16. He cleared an area in a dark and dangerous forest filled with things that were very scary.
17. Because he was scarier than the things in the forest, they abandoned the area and moved to another area.
18. And with his spade he raised a hill in the middle of the clearing not too high but just high enough and patted it down with his cosmic foot.
19. There was a thump vibrating through the heavenly body pronouncing the sacred nature of the hill.
20. He put the spade back in his toolbox and reached for the sharp long metal rod.
21. He then made several holes in the clearing mimicking the cosmic pattern of his divine nature.
22. He then scattered some tree seeds into the wholes around the clearing, some fruit trees that would provide fruit and food.
23. He put the sharp metal rod back in his toolbox and reached for his watering can.
24. Looking around he did not see a source of water and put the watering can to one side.
25. He reached back into his Toolbox and reached for a thicker, longer and sharper metal rod and a hammer a very, very big hammer.
26. He hopped to a place close to the hill and planted the tree there on the hill, close to where there was a little crevasse.
27. He looked at the crevasse and he placed the big long metal rod into a slit in the earth where it stood upright.
28. He raised his hammer upon high and he brought the hammer down onto the rod.
29. He nailed the rod into the crevasse.
30. He started driving his long thick metal rod into the small crevasse of the heavenly body.
31. He kept on hammering and hammering until the water came spouting out, exploding into the air.
32. The heavenly body releasing her fluids into the air, getting everything wet.
33. As he slipped his thick long metal rod from the earth's crevasse, the earth gave a sigh.
34. The spouting fountain turned into a babbling brook.
35. The sun and a gentle breeze started drying his fur.

Book of the Dead Bunny
Book of the Begotten

36. When he was dry, he took the hammer and the long thick metal rod back to the Toolbox where he put them away.
37. He went back to his watering can and went back to the brook to fill his can.
38. Once filled he started watering the places where he planted the trees.
39. The trees grew immediately as the first water reached the seedpods.
40. The clearing surrounded by the forest very soon became a beautiful place.
41. He sat back against the growing tree and looked at the clearing that surrounded him and he thought that this would be the perfect place for his first children.
42. As the sun set over the trees he started dreaming, he awoke in his dreams in the clearing and he knew what to do.
43. He slowly started speaking the loving words, the words that called his beloved ones.
44. The words weaved their way through time and space grabbing hold of the parts of magical dust that brought his beloved together.
45. Although part of what was made the webs brought together the beloved's spirits.
46. As well as those that were destined to be their loved ones.
47. The dreams went further and brought together the spirits of the beloved with what was already made.
48. Not only the spirits of his beloved but those of their kin.
49. As the dream wove its tentacles, the great one knew.
50. He watched the clearing fill up with the bodies and spirits of the first ones to live here, the ones that would form the first group.

Book of the Dead Bunny
Book of the Begotten

4. THE SECRET DEVIATION

1.	Once the plan was settled his mind wondered into his contemplations about the road and the journey that was about to start.
2.	It was the crossing that occupied in his mind.
3.	He tried to find his way around the crossing of the two paths and realised that any other option would not lead to the great discovery.
4.	The discovery event, though by chance, would be the turning point for the heavenly body.
5.	The crossing of the paths would see the transformation of the great one into whom would do great things.
6.	And this made his heart beat warmly despite the moment of instantaneous pain.

5. FINAL PREPARATIONS AND THE ARGUMENT

1.	After his mind returned from his contemplations, he decided on the final preparations for the clearing in the forest.
2.	He placed a man and woman there for no other reason but to name all the first ones.
3.	He did not regard the man and woman as important yet as they would only be important much later in the path that was laid out.
4.	He did not even bother giving them names as he knew some time in the future they would make up their own story.
5.	But for now they would need to serve their purpose.
6.	They looked at the creatures he loved the most on the plain and they named them; the bunnies.
7.	The humans were a funny sort, the Great Bunny knew their evolution and survival was important for the path he took but still thought that they were a bit of a waist at that time.
8.	The Great Bunny sat with one of the creatures that did not live in the clearing that he loved so much.

Book of the Dead Bunny
Book of the Begotten

9. The creature was a snake and his name was KoosBoosDoosLoos.

10. The Great Bunny loved having chats with KoosBoosDoosLoos from time to time, he felt a bit sorry for KoosBoosDoosLoos as he did not know on this beautiful heavenly body any creature would want to live without the ability to jump.

11. He spoke to KoosBoosDoosLoos about these funny people that he had to take care of as the play an important part in the great work.

12. And how their time has come to an end for now and he wasn't sure what to do with them now.

13. He didn't like having them in his plain, they were going to mess up the path for the bunnies and the rest of the creatures.

14. KoosBoosDoosLoos listened with interest and a bit of jealousy, as he wanted to serve the Great Bunny.

15. Eventually after some thought KoosBoosDoosLoos suggest that the Great Bunny play a joke on these people.

16. The Great Bunny listened with interest to KoosBoosDoosLoos' plan.

17. After hearing the plan the Great Bunny sat and thought it over for a bit.

18. KoosBoosDoosLoos sat and waited.

19. After some thought the Great Bunny started laughing and gave KoosBoosDoosLoos a pat on the back saying "that is the best idea I have ever heard. We will do it once they are finished with their work of naming things."

20. The Great Bunny went back to the plain giggling all the way.

21. Sometime passed and the Great Bunny eventually got tired waiting for the humans to finish their work.

22. They seemed to spend more time sitting around talking about nothing and complaining about
everything.

23. He decided that he will start the joke.

24. He decided that the Amarula tree would be the best one as the fruit was a useful fruit but interesting things would happen if you ate the fruit once it is overripe.

25. While the two people were sitting around talking about nothing much in particular, the Great Bunny projected his voice so it sounded like it was coming

Book of the Dead Bunny
Book of the Begotten

from behind the sun, one of those too hot to handle heavenly bodies.

26. And the voice said onto them, those pesky people: "from all the fruits in the in this garden you may eat of everything but the Amarula fruit."

27. They looked to the sun and looked away and asked: "but why can we not eat of this plant, oh sun?"

28. The Great Bunny shook his head in wonderment as to the stupidity and answered: "because I said so, if you disobey me you will feel the wrath of my displeasure."

29. He thought for a bit and as the man tried to ask another question, he interrupted the man...

30. "If you displease me I will make your life so difficult you will not have time to sit and chat your days away, you will have to leave and go and become power hungry, forgetting about the pleasures of the Sunny afternoons, having to work your back sides off."

31. The Great Bunny watched them think for a bit and when the man wanted to ask another question the Great Bunny carried on...

32. "I will make you not only work but become dependent on bad entertainment, get you to complicate your life with useless rules that you will place on yourself."

33. He watched them thinking about what was just said to them and as the man attempted to ask another question he interceded...

34. "Oh, bloody hangover, are you seriously trying my patience? If you do not follow my rules the great change will come faster to you than to the rest and then you will beg to return. You will cry and everything you do will hurt and drive you slowly to death and the worst of it all, you will do this to yourself. So, make your decision."

35. The man looked quietly at the woman and she opened her mouth to say something.

36. Before the Great Bunny could interrupt she spoke and would not be interrupted.

37. She said unto the Great Bunny: "who do you think you are being so rude to my man? We got your rule the first time, all we wanted to know was why. But if you do not even want to answer the question then why should we

Book of the Dead Bunny
Book of the Begotten

listen to you?"

38.	Before he could answer she carried on: "oh, don't bother obviously, you don't think we are clever enough to understand your reasons and if that is how you feel then fine we will follow your rule but stop underestimating us or you'll be sorry."

39.	The Great Bunny wanted to say something but decided that this will only end the day badly. The joke has been started and he hopped away.

40.	He went straight to KoosBoosDoosLoos and invited him to come and visit the plain.

41.	The Great Bunny and KoosBoosDoosLoos sat that evening and the dead bunny told KoosBoosDoosLoos of the interaction and KoosBoosDoosLoos just shook his head in amazement.

42.	As KoosBoosDoosLoos curled up and went to sleep. The Great Bunny observed the two people and the woman was still carrying on about the sun's rudeness.

43.	And the Great Bunny left.

44.	The next morning the woman was sitting under the Amarula tree wondering about the reasons for not eating the fruit of the tree and she wondered about the silliness of the rule.

45.	The man knew his woman and knew to leave her to her wonderings. Otherwise he would be asked about the reason for the rule and he would get in trouble for not knowing.

46.	As the woman sat there KoosBoosDoosLoos sailed into the tree and watched her for a bit.

47.	He saw some of the fruits on the ground and knew that they were well overripe.

48.	He cleared his throat and the woman looked at him and asked: "and who are you? I have never seen you around and I know we have not named you?"

49.	KoosBoosDoosLoos answered: "oh, I am just a creature from outside the plain, I am just here for a visit with one of my old friends. And who are you?"

50.	The woman answered: "I am the woman the only one of my kind and I am just sitting here Wondering about a new rule the sun made. I am sure he made it up because he has nothing else to do."

51.	KoosBoosDoosLoos knowing the truth decided to be truthful and answered: "as it happens I know the voice that came from the sun very well. He is the friend I am visiting…"

Book of the Dead Bunny
Book of the Begotten

52. She interrupted him and said: "so who does he think he is?"

53. KoosBoosDoosLoos answered: "he is the great one, and I know you should not eat the fruits from the tree because he said so, I might not know the reason but if he said so nobody will eat of the fruits from the tree."

54. She huffed and said softly: "I don't care if he can't even show himself. Why on this earth should we listen to him? We are naming everything and we are talking about everything, maybe he should rather listen to us…"

55. KoosBoosDoosLoos almost losing his temper decided to get the plan going and he said to the woman: "you know maybe he will get new respect for you if you found a way to not break his rule but still get to eat the fruit. But not from the tree. I believe he loves ingenuity and creative thinking…"

56. He let the idea settle in and as it were waiting for her to see his eyes Flashing between her and the fruits on the ground.

57. He realised that the woman was thinking, weighing up her options.

58. It was at that moment that the man arrived, and KoosBoosDoosLoos was happy at this.

59. The man asked wat was going on and who this Creature is, looking at the woman.

60. She didn't answer his question and just asked if he thought the rule included the fruits on the ground.

61. He looked at her and said that he wasn't sure.

62. The man and KoosBoosDoosLoos looked at the woman and then at each other.

63. They looked back and forth a couple of times.

64. And as the man looked at KoosBoosDoosLoos and opened his mouth, KoosBoosDoosLoos answered: "I am a snake and I am here visiting a friend."

65. The man just answered: "ok."

66. As they stood there, waiting for the woman to finally say something, KoosBoosDoosLoos gave the man one of the fruits of the ground and the man took a bite.

67. He took a bit, looked at the fruit and carried on eating.

68. Before long the man had finished a couple of fruits from

Book of the Dead Bunny
Book of the Begotten

the ground.

69. KoosBoosDoosLoos saw that the man was sort of tipsy.

70. The woman suddenly looked at the man in amazement and asked: "what did you just do?"

71. The man looked at the woman and answered in a slur: "I am not sure, but it is nice."

72. He gave the woman a fruit and she ate some of it and they sat down eating some more. They started to talk about stuff.

73. KoosBoosDoosLoos sat for a bit and watched this unfold.

74. Then KoosBoosDoosLoos left.

75. With nobody there to observe and the fruits flowing nobody except the Great Bunny knew what happened and he really wanted to forget.

76. The next morning KoosBoosDoosLoos and the Great Bunny started looking for the people, but they were nowhere to be found.

77. The Great Bunny thought this was marvellous.

6. AFTER THE FRUIT

1. It was weeks later that KoosBoosDoosLoos, slithering through the barren lands where he lived, came across the man sitting on a rock and looking into the distance and taking a fruit, the forbidden fruit from his bag.

2. KoosBoosDoosLoos asked the man what happened and how he is doing.

3. The man answered: "oh, it is you, you are to blame for this…"

4. KoosBoosDoosLoos asked: "to blame for what? You guys just disappeared."

5. The man looked at KoosBoosDoosLoos and said: "those fruits, we were having such a nice time. Then when I got a bit amorous, the wife or life partner as she calls herself started going on about the oppressive nature of the area. He is telling us what to do and what not and how we are not safe in the area and how we should see if there are other areas better suited to our life style, areas with a better growth potential … and we ate more fruit … the rest is a bit of a mystery but we woke up in a ditch, not sure where."

6. KoosBoosDoosLoos

Book of the Dead Bunny
Book of the Begotten

quietly asked: "and?"

7. And the man was quiet for a bit and then carried on with the story: "well she was angry about eating the fruit from the ground … and … well she accused me of getting us lost and not being able to get back to the garden, I lost my temper and told her to get the new home she wanted ready because I am going to get food and when I get back our house needs to be presentable."

8. KoosBoosDoosLoos totally engrossed by the tail asked again: "and?"

9. The man looked at KoosBoosDoosLoos and said: "she looked at me, stomped her foot and after a bit she slapped me and I left to get food."

10. KoosBoosDoosLoos gasped in amazement.

11. The man carried on and said: "well at least we got what she wanted…"

12. KoosBoosDoosLoos was amazed.

13. After having another fruit, he got up and said: "well now it is back to work for me, if we only listed to the sun when he warned us." He looked at the snake and said: "you are just as much to blame for all of this. I think the next time I see you I am going to step on your head and see how you like it to have your head rubbed in the sand."

14. KoosBoosDoosLoos watched as the man walked away and made a note to himself to avoid the man and those that come behind him from now on.

15. A couple of days later the Great Bunny came to visit KoosBoosDoosLoos and he told the Great Bunny the story.

16. The Great Bunny laughed and told KoosBoosDoosLoos: "well your plan worked and that makes me very happy."

17. KoosBoosDoosLoos felt a bit of pride in doing a good job.

18. The Great Bunny looked at KoosBoosDoosLoos and said: "it just struck me; people are the sort of creatures that would turn this into some kind of religious event and base some strange idea on these events."

19. KoosBoosDoosLoos agreed and said: "they would probably use one of us to blame it on and hate that one for the rest of time…"

20. The Great Bunny looked at KoosBoosDoosLoos and said: "your right and I think it might be you, they saw you."

Book of the Dead Bunny
Book of the Begotten

2. THE PRELUDE

1. A REST

1.	The Great Bunny sat down after all this work and rested for a bit under the tree in the clearing.
2.	He watched as the sun rose. He loved looking at the good work he half done.
3.	And thinking about it he particularly loved the joke he played on the people and he would remember to thank KoosBoosDoosLoos for sharing the idea with him the next time he saw him.

2. THE REAL BEGINNING

1.	The plain was the most beautiful landscape one could have wished for.
2.	There were dense forests and hills surrounding the plain on all sides.
3.	Everybody on and in the plain enjoyed the melodious songs of the birds that came from the trees, on the plain in the mornings and in the evenings as the sun sets.
4.	Scattered around the plain were wild fruit trees with the most wonderful fruit hanging heavily from their branches.
5.	And there was enough for everybody to eat, a perfect balance.
6.	In the middle of the plain was a pool of water that brought forth the sweetest clearest spring water.
7.	The pool was nestled amongst an outcrop of rocks.
8.	The rocks were a wonderful place for all the creatures from the plain to meet and talk and just to let the days wonder past.
9.	All who met there gave thanks to the Great Bunny because they knew his beloved

Book of the Dead Bunny
Book of the Begotten

two bunnies lived among them.
10. They were the two bunnies he spent most of his time with and
obviously, he loved them more than anybody else.
11. The Great Bunny spent a lot of time with everybody on the grassy plain.
12. But more so with his two beloved bunnies.
13. He sat with them and taught them about the seasons changing and how it all fits together as much as they needed to know for now.
14. He taught them about winter and the great sleepy, when all good little critters and some big ones went to sleep and rested before the coming of a new season.
15. The Great Bunny loved Spending his time in the Paradise, he created for his creatures.

3. HIS BELOVED

1. His beloved bunnies were there on and in the plain since they could remember.
2. They were never sure when they arrived and how they came to be there, but they knew they were always there.
3. Time did not mean a thing. All they knew was the passing of the Seasons. One season following on the other only broken by the great sleepy.
4. Their warren came into being when the Great Bunny first set his mind and feet on the plain and the ground moved and opened up a Special safe place in the ground Under the greatest tree, an Amarula tree, close to the pool of water on a hill from where they could see the whole plain.
5. They were thankful for this wonderful place in which they lived and enjoyed the passing of time.
6. The plain was a good place; it was green throughout spring and summer and as autumn arrived the days were shorter but still warm and as winter settled in over the plain the two bunnies laid down to rest for this time as the Great Bunny

Book of the Dead Bunny
Book of the Begotten

commanded to do in their warren.

7. Their winter rest was called the great sleepy.

8. It was with great pride that the Great Bunny watched the first two, not one before the other, both together and both dependant on each other.

9. He named them Floppsy and Flossy and they loved their names and each other, as was his will and his joy.

10. They were his beloved ones and he taught them the skills to make the warren their special home with lots of tunnels and lots of places to sleep and crawl.

11. He taught them and the other creatures on the plain what to eat and where to find the best food.

12. He loved them all and most of all he loved his two bunnies.

13. They were for now his chosen critters.

14. They did not yet understand why but they followed his instructions as they were commanded, for they loved the Great Bunny and not following his instructions was unthinkable.

15. This was their life: getting up in the morning as the sun rose, having some food playing around with the other critter, having some lunch, playing some more, sometimes inventing new games, sitting at the pool of water, talking some more and if the Great Bunny was there listening to his instructions, having another snack and as the sun set they would all go their homes and sleep.

16. Getting up in the morning as the sun rose, having some food playing around with the other critters, having some lunch, playing some more, sometimes inventing new games, sitting at the pool of water, talking some more. And if the Great Bunny was there, listening to his instructions, having another snack and as the sun set they would all go their homes and sleep.

17. Getting up in the morning as the sun rose, having some food playing around with the other critters, having some lunch, playing some more, sometimes inventing new games, sitting at the pool of water, talking some more. And if the Great Bunny was there listening to his instructions,

Book of the Dead Bunny
Book of the Begotten

having another snack and as the sun set they would all go their homes and sleep.

18. Getting up in the morning as the sun rose, having some food playing around with the other critters, having some lunch, playing some more, sometimes inventing new games, sitting at the pool of water, talking some more. And if the Great Bunny was there listening to his instructions, having another snack and as the sun set they would all go their homes and sleep.

19. Getting up in the morning as the sun rose, having some food playing around with the other critters, having some lunch, playing some more, sometimes inventing new games, sitting at the pool of water, talking some more. And if the Great Bunny was there listening to his instructions, having another snack and as the sun set they would all go their homes and sleep.

20. Getting up in the morning as the sun rose, having some food playing around with the other critters, having some lunch, playing some more, sometimes inventing new games, sitting at the pool of water, talking some more. And if the Great Bunny was there listening to his instructions, having another snack and as the sun set they would all go their homes and sleep.

21. Getting up in the morning as the sun rose, having some food playing around with the other critters, having some lunch, playing some more, sometimes inventing new games, sitting at the pool of water, talking some more. And if the Great Bunny was there listening to his instructions, having another snack and as the sun set they would all go their homes and sleep.

22. Getting up in the morning as the sun rose, having some food playing around with the other critters, having some lunch, playing some more, sometimes inventing new games, sitting at the pool of water, talking some more. And if the Great Bunny was there listening to his instructions, having another snack and as the sun set they would all go their homes and sleep.

23. Getting up in the morning as the sun rose, having some food playing around

Book of the Dead Bunny
Book of the Begotten

with the other critters, having some lunch, playing some more, sometimes inventing new games, sitting at the pool of water, t alking some more. And if the Great Bunny was there listening to his instructions, having another snack and as the sun set they would all go their homes and sleep.

24. Getting up in the morning as the sun rose, having some food playing around with the other critters, having some lunch, playing some more, sometimes inventing new games, sitting at the pool of water, talking some more. And if the Great Bunny was there listening to his instructions, having another snack and as the sun set they would all go their homes and sleep.

25. Getting up in the morning as the sun rose, having some food playing around with the other critters, having some lunch, playing some more, sometimes inventing new games, sitting at the pool of water, talking some more. And if the Great Bunny was there listening to his instructions, having another snack and as the sun set they would all go their homes and sleep.

26. Getting up in the morning as the sun rose, having some food playing around with the other critters, having some lunch, playing some more, sometimes inventing new games, sitting at the pool of water, talking some more. And if the Great Bunny was there listening to his instructions, having another snack and as the sun set they would all go their homes and sleep.

27. Getting up in the morning as the sun rose, having some food playing around with the other critters, having some lunch, playing some more, sometimes inventing new games, sitting at the pool of water, talking some more. And if the Great Bunny was there listening to his instructions, having another snack and as the sun set they would all go their homes and sleep.

28. Getting up in the morning as the sun rose, having some food playing around with the other critters, having some lunch, playing some more, sometimes inventing new games, sitting at the pool of water, talking some more. And if the Great Bunny was there listening to his instructions,

Book of the Dead Bunny
Book of the Begotten

having another snack and as the sun set they would all go their homes and sleep.

29. Getting up in the morning as the sun rose, having some food playing around with the other critters, having some lunch, playing some more, sometimes inventing new games, sitting at the pool of water, talking some more. And if the Great Bunny was there listening to his instructions, having another snack and as the sun set they would all go their homes and sleep.

30. Getting up in the morning as the sun rose, having some food playing around with the other critters, having some lunch, playing some more, sometimes inventing new games, sitting at the pool of water, talking some more. And if the Great Bunny was there listening to his instructions, having another snack and as the sun set they would all go their homes and sleep.

31. Getting up in the morning as the sun rose, having some food playing around with the other critters, having some lunch, playing some more, sometimes inventing new games, sitting at the pool of water, talking some more. And if the Great Bunny was there listening to his instructions, having another snack and as the sun set they would all go their homes and sleep.

32. Getting up in the morning as the sun rose, having some food playing around with the other critters, having some lunch, playing some more, sometimes inventing new games, sitting at the pool of water, talking some more. And if the Great Bunny was there listening to his instructions, having another snack and as the sun set they would all go their homes and sleep.

33. Getting up in the morning as the sun rose, having some food playing around with the other critters, having some lunch, playing some more, sometimes inventing new games, sitting at the pool of water, talking some more. And if the Great Bunny was there listening to his instructions, having another snack and as the sun set they would all go their homes and sleep.

34. Getting up in the morning as the sun rose, having some food playing around with the other critters, having

Book of the Dead Bunny
Book of the Begotten

some lunch, playing some more, sometimes inventing new games, sitting at the pool of water, talking some more. And if the Great Bunny was there listening to his instructions, having another snack and as the sun set they would all go their homes and sleep.

35. Getting up in the morning as the sun rose, having some food playing around with the other critters, having some lunch, playing some more, sometimes inventing new games, sitting at the pool of water, talking some more. And if the Great Bunny was there listening to his instructions, having another snack and as the sun set they would all go their homes and sleep.

36. Getting up in the morning as the sun rose, having some food playing around with the other critters, having some lunch, playing some more, sometimes inventing new games, sitting at the pool of water, talking some more. And if the Great Bunny was there listening to his instructions, having another snack and as the sun set they would all go their homes and sleep.

37. Getting up in the morning as the sun rose, having some food playing around with the other critters, having some lunch, playing some more, sometimes inventing new games, sitting at the pool of water, talking some more. And if the Great Bunny was there listening to his instructions, having another snack and as the sun set they would all go their homes and sleep.

38. Getting up in the morning as the sun rose, having some food playing around with the other critters, having some lunch, playing some more, sometimes inventing new games, sitting at the pool of water, talking some more. And if the Great Bunny was there listening to his instructions, having another snack and as the sun set they would all go their homes and sleep.

39. Getting up in the morning as the sun rose, having some food playing around with the other critters, having some lunch, playing some more, sometimes inventing new games, sitting at the pool of water, talking some more. And if the Great Bunny was there listening to his instructions, having another snack and as the

Book of the Dead Bunny
Book of the Begotten

sun set they would all go their homes and sleep.

40. Getting up in the morning as the sun rose, having some food playing around with the other critters, having some lunch, playing some more, sometimes inventing new games, sitting at the pool of water, talking some more. And if the Great Bunny was there listening to his instructions, having another snack and as the sun set they would all go their homes and sleep.

41. Getting up in the morning as the sun rose, having some food playing around with the other critters, having some lunch, playing some more, sometimes inventing new games, sitting at the pool of water, talking some more. And if the Great Bunny was there listening to his instructions, having another snack and as the sun set they would all go their homes and sleep.

42. Getting up in the morning as the sun rose, having some food playing around with the other critters, having some lunch, playing some more, sometimes inventing new games, sitting at the pool of water, talking some more. And if the Great Bunny was there listening to his instructions, having another snack and as the sun set they would all go their homes and sleep.

43. And this was their life.

44. One particular autumn, as they were getting ready for the great sleepy, making sure that their home was nice and comfortable and they had enough fat on their bodies they got the feeling that something was different but they did as they were instructed by the Great Bunny.

45. They were ready for the great sleepy for they knew this would please the Great Bunny.

Book of the Dead Bunny
Book of the Begotten

4. MEETING BEFORE WINTER SLEEPY

1. As the first day of the winter arrived Floppsy and Flossy were getting ready for the great sleepy by enjoying the last bit of warm sun light at the pool.
2. They found no other creature around and even the birds were quiet.
3. They were the last to go too sleepy.
4. This was one of their special times with the Great Bunny, saying good night.
5. As the sun touched the tops of the trees, they heard the sound of the Great Bunny approaching.
6. They waited for him to join them as he always did before the great sleepy took them to spring.
7. As he arrived, his beloved came to him and they greeted him with the love and respect they felt for him.
8. He greeted them as he did with love and a fuzzy heart pumping carrot juice because they were his beloved.
9. They started bouncing to their warren talking and listening to the Great Bunny.
10. The Great Bunny said onto them: "go and rest now as I have taught you to rest because I love you as I do. Remember that not I or anybody else understands what you will be awakening to and no one will warn you of the unbeknown that awaits you except me, so be warned of the unbeknown."
11. His words sounded strange to them as this was unlike his normal loving words to them before the great sleepy.
12. They stopped and were silent for a bit thinking about these strange words.
13. Floppsy then asked with the greatest of humility because he feared the unseen and possible wrath of the Great Bunny: "oh, but please tell us what is awaiting us for your words are different from your normal goodnight to us?
14. What is this unbeknownst? It fills my heart with fear.
15. Is it down in our house from which this unbeknownst thing will come?
16. Is it from the sky that this thing that nobody understands will come?
17. Or even worse, is it from within ourselves that this mysterious thing will erupt and

Book of the Dead Bunny
Book of the Begotten

fill this heavenly place we all love?
18. Or from the front or the back or the sides?"
19. Floppsy looked at the Great Bunny, his eyes filling with fear and tears.
20. The Great Bunny looked with surprise at Floppsy and Flossy and stroking their ears as their ears were soft and reminded the Great Bunny of his own ears and how he liked them to be touched.
21. The Great Bunny said onto them: "go and rest and you will have nothing to worry about.
22. Go now and rest and spring will be the start of something which is unbeknown to you but not me and if I command you to sleep, you should go and sleep now.
23. If you don't you will not love and enjoy the thing that is unexpected as I love you and enjoy my time with you, so go now as you are commanded and know I love you both as my own for you are my own.
24. You are from me as I am from you, I give to you and you give to me."
25. Floppsy and Flossy unsure of the meaning of the Great Bunny's words said their goodnight and crawled into their warren.
26. The Great Bunny watched them crawl into their warren and giggled to himself as he knew what was coming in the spring with the first blooming of the flowers, a time he loved so much that will only now come to its full purpose for all the critters.
27. Floppsy heard the giggle of the Great Bunny and was f earful and concerned, but he did as they were commanded.

Book of the Dead Bunny
Book of the Begotten

5. IN THE DARKNESS

1. Floppsy followed Flossy deep into warren, with his heart slowly growing heavy with fear and concern.
2. Floppsy knew he was never to question the Great Bunny, but the Great Bunny's words weighed heavy on his heart and his ears drooped when he crawled through the holes to where they would sleep the great sleepy.
3. In Floppsy's heart of hearts the fear grew and weaved concern around him like a worm weaves his cocoon, he tried to hide his concern from his beloved Flossy.
4. They were curled up against each other and Floppsy asked Flossy: "do you wonder of what is waiting for us that is unbeknown?"
5. Flossy replies with sleep heavy in her voice: "no, I do not know what is waiting for us and neither am I worried about what is waiting for us"
6. Floppsy asked: "why are you not worried?"
7. Flossy replies: "if he, who loves us the most said to rest and not to worry then that is his command and we should do as instructed."
8. Floppsy asked: "did you not hear his giggle as we came inside?"
9. Flossy replies: "no, it must have been your imagination or eating too much celery or the wind rustling through the wintery grass or something you silly billy bunny."
10. Floppsy replied doubtfully: "yes, it must have been something or the other."
11. And they both went off to sleep as they were commanded.
12. As Flossy was drifting off to sleep, she started wondering about Floppsy's questions.
13. She started wondering about the unbeknownst waiting for them with the start of spring.
14. Her mind unexpectedly started exploring all the possibilities of the unbeknownst and as her mind found something that was unbeknown to her, it dawned on her that she now knows it and it was not unbeknown to her anymore and then she had to try and think of something else unbeknown to her.
15. Eventually, within a short period of time this process became difficult for her to carry on with.

Book of the Dead Bunny
Book of the Begotten

16. This process started making her uncomfortable and she tossed and turned.
17. Floppsy became aware of Flossie's tossing and turning and nudged her in the ribs.
18. She did not come to rest or allowed sleep to befall her wondering mind.
19. With sleep still chasing her mind as the moon chased the sun or a hooting owl would chase after a bunny and this thought striking her as strange as no owl has ever chased after a bunny before, Flossy rested her head on her elbow.
20. She asked Floppsy: "why are you sleeping, my beloved Floppsy?"
21. Floppsy answered: "why should I not sleep as commanded by him who loves us the most?"
22. Flossy answered: "because of that which is unbeknownst to us, it is not giving me comfort, neither is the Great Bunny's words of comfort and you should not get any comfort in resting when my mind is in distress, your questions and worry is the cause of this unrest in my mind."
23. Floppsy, now being dragged out of his slumber turned, looking into the face of his beloved Flossy and said to her: "my dear, your words gave me rest and invited sleep to enter the whole of my mind. If he who loves us the most said to rest and not to worry, then that is his command and we should do as instructed.
24. With your kind and sweet words in my mind and heart, I beg you to do as commanded and not to concern yourself with that which will be resolve with the start of spring."
25. Floppsy thought that these words would be enough for Flossy as they were for him.
26. She truly hoped that hearing these words of assurance from her dear Floppsy's mouth would calm her down and let sleep take her.
27. But she was wrong and her mind wondered.

Book of the Dead Bunny
Book of the Begotten

6. THE PILLOW QUESTIONING

1. Flossy tried again to fall asleep, but Floppsy's words did not help her at all.
2. Flossy said to him: "my mind is hopping around each and every tree of my imagination exploring and trying to find a clue as to what is the unbeknown thing is that awaits us in the spring.
3. My mind keeps on looking and looking.
4. And as soon as I find a clue that leads me to a place that will reveal that which is unbeknownst to us.
5. It leads me to find a thing, and once I find the thing and I know the thing I know it and it is not unbeknown to me anymore.
6. I then realise that it cannot be the thing that is unbeknownst to us.
7. So the unbeknown still remain a mystery to me, as the reason for the orange colour of Carrots remains a mystery to me"
8. Floppsy looked at her and sighed: "would you like to talk about your thoughts and suspicions on the thing that will remain unbeknownst to us?"
9. Flossy looked at Floppsy and said: "I would, but what is the use of words when it comes to the secret of the unbeknown?
10. I do so wish he who loves us the most did not speak of that which is unbeknown to us.
11. This only creates a warren of the mind, with no place to come in and no place to leave the dark and uncomfortable tunnels."
12. Floppsy and Flossy continued to discuss that which is unbeknown to them and their words echoed through the tunnels.
13. The Great Bunny was quietly sitting outside listening to their discussions with a smirk on his face.
14. They dug up many possibilities of what this unbeknown thing or event could possibly be.
15. After several hours of discussion, Flossy turned too Flossy and said: "maybe the answer to that, which is unbeknown to us, does not lie in the unbeknown but rather in him who loves us the most?
16. Maybe if we knew the Great Bunny better, then we would be able to understand what he meant when he said that

Book of the Dead Bunny
Book of the Begotten

which is unbeknown to us?"
17. Floppsy sat up and looked at Flossy with uncertainty, he was not sure if this would be a good idea.
18. He said to her: my dear, are you sure these wonderings will bring light to the Maze of tunnels in which you find yourself?
19. Are you sure that this will be the right hole to crawl into?"
20. Flossy gave these words some thought and decided not to let her wonderings stop there.
21. After sometime, she turned to Floppsy and said: "he who loves us the most is a mystery, is it not so that we love each other and we know all there is to know about each other?
22. Is it not true that we know all about each other because we love one another as much as we do?
23. Is it not so that he knows all of us, because he loves us as much as he does?
24. And if we know nothing about him that loves us the most, how can we truly love him as he loves us and as we love each other?
25. Floppsy listened to these words and after Flossy finished he felt as if he was chewing these words like a stick of celery that must have been in the sun for too long and has gone soft and funny.
26. He looked at her and said: "well then carry on with your questions. I am not sure that this is a hole that will lead somewhere where we want to go or that would lead to illumination."
27. Flossy started: "we are different, you are man and I am woman, so because he is he.
28. We call him, he, but do you know if he is a he, or is he a she?"
29. Floppsy looked at her thinking that he would like the Great Bunny to be him, he was not sure if that would matter because if the Great Bunny was like me a he, they would be alike and that would be good because he loved himself.
30. If the Great Bunny was a she, he would love the Great Bunny the same as he loves Flossy.
31. For him this became very strange to think about and he decided that this did not matter.
32. So he said too Flossy: "I do not know and I do not think it matters because if he was a him I would love him the same as I love myself.
33. If he was a she I would

Book of the Dead Bunny
Book of the Begotten

love her the same as I love you.
34. And I love you the same as I love myself.
35. Flossy listened to Floppsy and said: "that is the same for me, but is it the same for the Great Bunny? Does he treat us the same?
36. Floppsy looked at Flossy with a great curiosity and said: "I do not know, I do not think so, we have always called the Great Bunny a he."
37. Flossy commented that he has never heard us calling him a he.
38. Floppsy ignored the comment and carried on:
39. "But he has never made one of us better or faster or more special than the other. We are just... different."
40. Flossy's eyes went as wide as the biggest fruit Floppsy has ever seen and she said: "what if we have been wrong for so long and he is she and the unbeknown is our punishment for not addressing her in the right way."
41. Fear suddenly grabbed hold of Floppsy's heart and this thought ran through is mind.
42. He opened his mouth to explore the terror that this thought awoke in him but no words came from him.
43. Silence came between Flossy and Floppsy.

Book of the Dead Bunny
Book of the Begotten

Book of the Dead Bunny
Book of the Begotten

44. Floppsy eventually opened his mouth and spoke: "that cannot be.
45. He or she would have corrected us when we first made the mistake. I am sure of that.
46. We have made many mistakes and he or she made us see our mistakes with love and care.
47. There has never been punishment, ever!"
48. Flossy looked at Floppsy and sighed. Floppsy heard the relief in her voice when she said: "yes that is true, so true.
49. But does that mean he is a he?"
50. Floppsy shook his head and said with anger and frustration heavy in his voice:
51. "Have you seen Whether he is a he or a she?"
52. Flossy shook her head and Floppsy continued:
53. "These questions will not lead us down a hole that will give us illumination.
54. We do not know if he is a him or her and if it is not a problem calling him, him, then that is good."
55. Floppsy now filled with rage and frustration continued:
56. We do not know if he is a he or a she.
57. We do not know how old he is.
58. We do not know if he sleeps.
59. If he sleeps, we do not know how long he sleeps.
60. If he sleeps, we do not know if he dreams.
61. If he dreams, we do not know what he dreams.
62. If he dreams, we do not know if he has pleasant dreams.
63. If he dreams, we do not know if he has scary dreams.
64. If he dreams, we do not know if his dreams come true.
65. We do not know if he is just dreaming us.
66. We do not know if his dreams are true.
67. We do not know where he comes from before the plain.
68. We do not know what he did before the plain.
69. We do not know where he comes from when he visits us.
70. We do not know what he did before he comes to visit us.
71. We do not know if there are more of him.
72. If there are more of him, we do not know how many there are.
73. If there are more of him,

Book of the Dead Bunny
Book of the Begotten

we do not know what they look like.
74. If there are more of him, we do not know if they are as kind as he has been.
75. If there are more of him, we do not know how they fill their time.
76. We do not know if he has any friends.
77. If he has friends, we do not know how many friends he has.
78. If he has friends, we do not know what sort of friends he has.
79. If he has friends, we do not know what they look like.
80. If he has friends, we do not know how much time he spends with them.
81. If he has friends, we do not know what they like to do together.
82. If he has friends, we do not know if they always get along.
83. If he has friends, we do not know if they are bigger or smaller that he is.
84. If he has friends, we do not know if they like to play games together.
85. If he has friends, we do not know what type of games they like to play.
86. If he has friends, we do not know of, we do not know why he has not told us about them.
87. If he has friends that he has never told us about, we do not know why he has not told us about them.
88. We do not know if he has someone that loves him as I love you apart from us.
89. If he has someone that that loves him as I love you apart from us, if that one is a he or a she.
90. If he has someone that that loves him as I love you apart from us, if that one is bigger or smaller than he is.
91. If he has someone that that loves him as I love you, apart from us, if that one is as kind as he is.
92. If he has someone that that loves him as I love you, apart from us, if he visits that one more or less than he visited us.
93. If he has someone that that loves him as I love you, apart from us, where that one lives.
94. If he has someone that that loves him as I love you, apart from us, if that one is actually alive or dead.
95. If he has someone that that loves him as I love you, apart

Book of the Dead Bunny
Book of the Begotten

from us, we do not know why he has not told us about the one.

96. We do not know if he has other bunnies that he visits.

97. If he has other bunnies he visits, we do not know if he loves them more than us.

98. If he has other bunnies he visits, we do not know if he loves them less than us.

99. If he has other bunnies he visits, we do not know if he loves them the same as us.

100. If he has other bunnies he visits, we do not know how many of them there are.

101. If he has other bunnies he visits, we do not know if they look the same as us.

102. If he has other bunnies he visits, we do not know what sort of bunny they are.

103. If he has other bunnies he visits, we do not know if he has taught them what he taught us.

104. If he has other bunnies he visits, we do not know if he taught them more than he taught us.

105. If he has other bunnies he visits, we do not know if he taught them less than he taught us.

106. If he has other bunnies he visits, we do not know if they are as happy as we are.

107. If he has other bunnies he visits, we do not know why he has not told us about them.

108. We do not know if he eats anything, because we have never seen him eat.

109. If he eats anything, we do not know what he likes to eat.

110. If he eats anything, we do not know what he does not like to eat.

111. If he likes to eat anything, we do not know how much he eats.

112. If he eats anything, we do not know if he eats the same way as we eat.

113. If he likes to eat anything, we do not know where he gets his food.

114. If he likes to eats anything, we do not know how much he eats.

115. If he likes to eats anything, we do not know if he loves us as much as he does because he likes to eat us.

116. We do not know if he lives somewhere.

117. If he lives somewhere, we do not know if it is his home.

118. If he lives somewhere, we do not know if his home is also a hole in the ground.

119. If it is a hole in the ground, we do not know how

Book of the Dead Bunny
Book of the Begotten

deep his hole is.
120. If it is a hole in the ground, we do not know how many tunnels he has.
121. If it is a whole in the ground, we do not even know if he made it with his Paws, as he taught us to do.
122. If it is a whole in the ground, we do not even know if someone else made it for him.
123. If it is not a hole, does he live in a tree?
124. If it is a tree, which tree would it be?
125. If it is a tree, does the tree bear fruit?
126. If it is a tree, what fruit does the tree bear?
127. If it is a tree and it bears fruit, is the fruit edible?
128. If it is a tree and it bears fruit, is the fruit poisons?
129. If it is a tree, it bears fruit, and the fruit is poisonous, how poisonous is the fruit?
130. If it is a tree, it bears fruit, and the fruit is poisonous, what happens when you eat the fruit?
131. If it is a tree does he live in the trunk,
132. If it is a tree and the trunk of the tree does the hole in the trunk go up or down?
133. If it is a tree, does he live in the branches?
134. If it is a tree and in the branches, does the tree, stay green all the time?
135. If it is a tree and in the branches, does the tree loos all its leaves in the winter?
136. If it is a tree, in the branches during winter and the tree has lost all its leaves, does he stay or move to another tree?
137. If it is not a hole or a tree does he stay in a cave?
138. If it is a cave, how big is the entrance to the cave?
139. If it is a cave how deep is the cave?
140. If it is a cave, is the cave warm?
141. If it is a cave, is the cave cold?
142. If it is a cave, is the cave damp?
143. If it is a cave, is the cave dry?
144. If it is a cave, are there other things in the cave?
145. If it is not a hole, a tree or a cave does he live in the sun?
146. If it is the sun, what does he do at night when there is no sun?
147. If it is the sun, does the sun not become too hot?
148. If it is the sun, how does he get to the sun?
149. If it is the sun, how does

Book of the Dead Bunny
Book of the Begotten

he get down from the sun?
150. If it is the sun, and he oversleeps, what happens when the sun disappears?
151. If it is not a hole, a tree, a cave or the sun, does he live on the moon?
152. If it is the moon, does he sleep in the curvy area of the moon?
153. If it is the moon, where does he sleep when the moon disappears?
154. If it is the moon, where does he sleep when the moon is totally round?
155. If it is the moon, what does he do during the day if he wants to take a nap or if it is raining and there is no moon?
156. If it is the moon, what happens if he oversleeps and the moon disappears behind things?
157. If it is not a hole, a tree a cave, the sun, the moon, does he live on the clouds?
158. If it is the clouds, we do not know what he will do when there are no clouds and he wants to go sleep.
159. If it is the clouds, we do not know if he lives in low clouds.
160. If it is the clouds, we do not know if he lives in high clouds.
161. If it is the clouds, we do not know if he lives in clouds somewhere in the middle?
162. If it is the clouds, we do not know if he lives in normal clouds.
163. If it is the clouds, we do not know if he lives in dark clouds.
164. If it is the clouds, we do not know if he lives in clouds with rain.
165. If it is the clouds, we do not know if he lives in clouds with
Thunder.
166. If it is the clouds, we do not know how he gets to the clouds.
167. If it is the clouds, we do not know how he gets back from the clouds.
168. If it is the clouds, we do not know what will happen if he is still sleeping and the cloud disappears.
169. If it is not a hole, a tree, a cave, the sun, the moon, the clouds, does he live in a nest?
170. If it is a nest, we do not know if he made the nest himself.
171. If it is a nest, we do not know if someone else made the nest.
172. If it is a nest and someone else made it, we do not know who made the nest.

Book of the Dead Bunny
Book of the Begotten

173. If it is a nest, we do not know what the nest is made of.
174. If it is a nest, we do not know how big the nest is.
175. If it is a nest, we do not know if the nest is in a tree, on the ground, in the sky or between rocks.
176. We do not know if he sees colours.
177. We do not know if he has a favourite colour.
178. If he has a favourite colour, we do not know what the colour is.
179. We do not know if he has a favourite time of day.
180. If he does have a favourite time of day, we do not know what that time of day it will be.
181. We do not know if he has a favourite time of the night.
182. If he has a favourite time of night, we do not know what time of night it will be.
183. We do not know if he has a favourite smell.
184. If he has a favourite smell, we do not know what that smell might be.
185. We do not know if he has a favourite taste.
186. If he has a favourite taste, we do not know what that taste might be.
187. We do not know if he can tell jokes.
188. If he can tell jokes, we do not know what type of jokes he might tell.
189. We do not know if he loves stories.
190. If he likes stories, we do not know what type of stories he likes.
191. We do not know if he likes
hearing stories.
192. We do not know if he loves telling stories.
193. We do not know if he likes
being busy.
194. If he likes being busy, we do not know what he likes to do.
195. We do not know if he likes
sitting around and resting.
196. We do not know where he likes to sit around and rest.
197. We do not know what he would do if he gets angry with us.
198. If he gets angry with us, we do not know what he would do.
199. We do not know why he has chosen us to live here.
200. We do not know what he has planned for us.
201. We do not know if the unbeknownst is something he has planned for us.

Book of the Dead Bunny
Book of the Begotten

202. We do not know if he has any control over the unbeknownst.
203. We do not know if he is simply a messenger for something greater than he is.
204. We do not know if he needs to clean himself.
205. If he has to clean himself, we do not know if he does it in the same way we do it.
206. We do not know if he likes to be touched.
207. If he likes to be touched, we do not know whom he likes touching him.
208. If he likes to be touched, we do not know where he likes to be touched.
209. If he does not like to be touched, we do not know why.
210. We do not know if he has to make droppings.
211. If he has to make droppings, we do not know where he makes them."
212. Floppsy was starting to feel very dizzy.
213. He has ranted for so long his anger and frustration has given up but he was not done.
214. Floppsy carried on: "we do not know what we should not know.
215. So please my love let us not make ourselves mad with everything that is unknown to us.
216. Let us go to sleep, please."
217. Flossy, shocked at Floppsy's response, looked at him and as his words hopped through her mind.
218. The truthfulness of his words dawned on her and illuminated their burrow.
219. Flossy snuggled in next to Floppsy and they both fell asleep.
220. Outside their warren the Great Bunny has been keeping his ear close to the opening of their burrow and giggled to himself listening to their discussion of that which remains unbeknown to them.
221. The cold wind was howling on the first evening of the sleepy and the Great Bunny decided that all was in place for coming of the unbeknown.
222. The Great Bunny whispered into the wind: "so let the thing begin."
223. He departed from the tree and went to the place where another thing that must happen, waiting for him.
224. And he was happy with the beginning.

7. SUMMER AWAKENING AND THE START OF THE UNBEKNOWNST

1. And spring started coming over the plain and all greeted the return of the warming sun.
2. The bunnies came out of their burrow and all was well with the world around them.
3. The trees started making new leaves.
4. New plants were coming out of the ground.
5. The birds were singing a new song greeting the coming of the sun.
6. They rested well and the thoughts for the unbeknown still buried deep in their memories of the crawling slumber.
7. The greeting of all the creatures were as always on this the first day of spring as joyful as a family meeting for the first time after a long absence.
8. They all hugged and kissed each other and made comments how well rested everybody looked.
9. After the initial greetings and salutations were completed, everybody became aware of the absence of the Great Bunny.
10. The Great Bunny always arrived to greet all of them after they greeted each other.
11. Silence came over the group of creatures and all turned their faces to the two who he loved the most.
12. The two felt the eyes on them in expectation of an explanation.
13. And they knew not what to say to the gathering.
14. Then the memories of the unbeknown came forth and comforted the two again.
15. Floppsy turned to all and he said to them: "he told us that an unbeknown was waiting for us after the sleepy."
16. The silence continued and Floppsy, trying to fill the silence, carried on: "we were not sure what this unbeknownst was; we tried to guess but stopped guessing before madness drove sleep from us during the sleepy."
17. Floppsy and Flossy looked at all that surrounded them.
18. The silence still carried on, the only disturbance was the flow of the water from the pool.

Book of the Dead Bunny
Book of the Begotten

Book of the Dead Bunny
Book of the Begotten

19. The others stared at them with eyes wide open and unsure of what was actually going on.
20. Floppsy and Flossy felt a silent panic coming over all gathered there.
21. Someone from the group started whispering: "does this mean the Great Bunny has abandoned us?"
22. And nobody could answer the question and silence returned to the gathering,
23. With all eyes still focused on Floppsy and Flossy.
24. A soft crying started to make its way through the group gathered.
25. But Floppsy suddenly said: "no, stop. This this is not the way it should be,
26. The Great Bunny never said goodbye!"
27. And silence returned again as the crying died down.
28. Flossy agreed with Floppsy and told everybody there: "the Great Bunny did not say goodbye, he only told us that there something unknown coming and that was all he told us, nothing more.
29. I am sure that if he were to leave us he would have said goodbye to me and Floppsy, the ones he loved so much.
30. If he did say goodbye, you know that we would tell you."
31. And there seemed to be some agreement settling over the group and the question came from them: "but where is he then and why is he not here?"
32. Floppsy looked at everybody in turn and asked the question: "if you want to drive yourselves mad with questions of why, where, when and how then please go ahead but Flossy and

Book of the Dead Bunny
Book of the Begotten

myself know better now after the madness of questions almost kept us awake during the great sleepy."

33. Flossy told them of the discussion she and Floppsy had about trying to make sense of the Great Bunny and his word of the unbeknown.

34. Everybody looked at them with wide eyes.

35. Flossy explained the moment that the Great Bunny mentioned as the unbeknown. Both of them started taking turns worrying and wondering about this unbeknown.

36. She carried on explaining that if it were not for Floppsy's stern words then it would have kept them up and wondering the during the entire great sleepy.

37. Once she finished telling their story Floppsy said: "if you want your minds to be stuck here in this place and time, then it will make you mad just like running around in golden circles constantly telling yourself you will be late."

38. And it seemed that a calm settled over the group.

39. Flossy said to them: "remember we do not know if he takes the sleepy, maybe he goes to another place, maybe he decided to stay longer where he went to.

40. We can only trust he is who he is and he will come back when it is time for him to return to us, who loves us"

41. And calm settled in full over everybody and there was a slow but steady return to the joyousness of the initial greeting.

42. As the first of the spring days rolled over the sky, everybody laughed, played and ate, as was the custom on the first day.

43. Everybody ate of the fresh new food and loved each other and every mouth was full of the plain's new crop.

44. As the day lingered on the men carried on playing and the women went to go and sit on the side of the field next to the river flowing into the forest.

45. The women sat close enough to where the men were playing, each watching and cheering for their mate.

46. The girls all sat close to each other and started to talk amongst themselves.

47. The men were not too concerned about this and carried on playing amongst themselves.

48. As the game carried on the men started playing harder and rougher.

49. The idea entered their

Book of the Dead Bunny
Book of the Begotten

minds that this would make them a better mate for their partner.
50. Although this was a very new and strange idea to the men, the idea seemed so natural and easy that the idea did not even become an idea that was present in their awareness.
51. The women started talking about the great sleepy and the first day being awake.
52. They became aware of the men and how rough they were playing.
53. One of the other creatures said: "I hope nobody gets hurt."
54. Softly everybody agreed but the thought left their minds as soon as the words were spoken.
55. The women followed the movements of their men in the game with a sharp eye.
56. Knowing and seeing what their partners were capable of and
admiring their game.
57. The men already playing to impress their partners, played even harder.
58. The sun started setting behind the trees of the forest. The game ended and everybody said their goodbyes already excited about seeing each other again the next morning.
59. And quietly hoping for the
return of the Great Bunny.
60. As everybody departed from the pool in the middle of the plain on their ways to their homes, they were all aware that something was different.
61. Nobody could or wanted to put it in words but everybody knew there was something different.
62. They all departed.

Book of the Dead Bunny
Book of the Begotten

8. THE UNBEKNOWNST REARS ITS HEAD

1. As darkness fell over the plain, Floppsy started feeling very peculiar.
2. He watched Flossy bounce closer and closer to the warren.
3. There was a smell wafting in the air.
4. Floppsy knew the smell was coming from Flossy.
5. The smell did something to him; he was not sure what but it caused everything to change within him.
6. He paid particular attention to the movement of her buttocks, the setting sun seemingly brightening her fur, the way her ears moved, the perfect proportions of her body as she hopped to the warren.
7. He started getting a feeling in his loins.
8. Floppsy could not explain this feeling but he knew it was not familiar feelings to him.
9. He could not and did not want to explain the feeling in his loins.
10. He was terrified of this new feeling but it excited him.
11. He knew the way he was looking at Flossy was different, but it seemed that there was something more, something swelling up inside him.
12. The only reason he could think of that caused these feelings was Flossy's smell, it made his head funny and it made his body feel strange.
13. Flossy bounced closer to the warren and after a nice relaxing day she knew something was happening, she was bouncing to the warren in a way that she could not explain.
14. She could not explain why she was bouncing differently but there was a desire in her to carry on.
15. She also became aware of a feeling between her legs and she was perplexed.
16. She was unsure about this feeling and chose not to pay any attention to this.
17. As they were bouncing both in their silence, they wondered if they were ill.
18. They thought that they might die and wondered if this was the unbeknownst: that they would die.
19. As they got closer to their warren, they realised that the feeling was not an illness,

Book of the Dead Bunny
Book of the Begotten

something awkward or anything they have ever known.
20. The best way they could describe this feeling to themselves was a feeling of wanting.
21. Both thought that this wanting was maybe a feeling they both felt for the possible loss of the Great Bunny.
22. They realised that this could not be, as they did not feel sorrow or loss.
23. It was just a wanting.
24. But wanting what?
25. They came close to the entrance of the warren and Floppsy could not take this feeling anymore and he knew Flossy was ready, he did not know how he knew but he knew.
26. And he did not know what she was ready for but he knew she was ready.
27. Flossy knew it was coming she did not know what but she was ready and so was Floppsy.

9. THE UNBEKNOWNST BANGS ITS HEAD

1. Floppsy notices that something between his legs has grown and has become as hard as a carrot.
2. But it was not a carrot, he was not a carrot.
4. It was like a stick, but it was not a stick.
5. Floppsy's twiggles, his carrot stick thing made his head go funny.
6. It was swollen and fluffy like a pillowy place and redish and pink, very very pink.
7. Floppsy wanted to get to Flossy's slippery when wet place and this confused him terribly.
8. He wanted to be inside her fluffle
9. As Flossy jumped behind Flossy and the smell became stronger and he could see her fluffle.
10. It was calling to him, like it wanted him as well.
11. This pinkish redish swollen fluffle protrusion made him very excited, so excited he did not know what to do with Himself.
12. And then the red mist came and clouded both their minds, leaving only fragments of

Book of the Dead Bunny
Book of the Begotten

thoughts.
13. Floppsy jumped on Flossy from behind.
14. He was not sure why he did this, his twiggles made him do it.
15. And it was strange that Flossy did not get a fright or fought with him
16. He felt his twiggles as hard as a rock slip into her warm wet fluffle.
17. There was something that made him move back and forth a couple of times, hard and fast and then, and then it was over.
18. Neither knew what happened but they knew something happened.
19. As soon as they did the thing they did not know the name of, both of them went to sleep.
20. As soon as either one of them stirred or moved, Floppsy's twiggles was hard and Flossy's fluffle was wet and they did it again and again and

Book of the Dead Bunny
Book of the Begotten

again and again and again and
again and again and again and
again and again and again and
again and again and again and
again and again and again and
again and again and again and
again and again and again and
again and again and again and
again and again and again and
again and again and again and
again and again and again and
again and again and again and
again and again and again and
again and again and again and
again and again and again and
again and again and again and
again and again and again and
again and again and again and
again and again and again and
again and again and again and
again and again and again and
again and again and again and
again and again and again and
again and again and again and
again and again and again and
again and again and again and
again and again and again and
again and again and again and
again and again and again.
21. Eventually when they both were tiered, Flossy was lying awake while Floppsy was sleeping just wondering about these things that happened, these things that she did not understand or knew of but enjoyed so much.
22. She heard Floppsy mumbling: "he will never come back the same…"
23. She was disturbed by these words despite a glow warming her, but the concern she felt was overcome by the exhaustion she felt.
24. She fell asleep.
25. Flossy forgot these words in the events that followed.
26. When the morning came over the forest trees, Flossy woke up and went out into the morning air and hopped through the long grass on the plain.
27. She knew something had happened and she was not sure what had happened and slowly it dawned on her as this new dawn broke, maybe, just maybe this was the unbeknown.
28. She was almost sure that this was the unbeknown.
29. But she could not shake the feeling that there was more to this thing that was the unbeknown.
30. She could not put her finger on what it could be.
31. It was early in the morning and she was thankful of the quiet that lay over the plain.
32. As she was quietly

Book of the Dead Bunny
Book of the Begotten

bouncing her way to the pool to sit and think.
33. She became aware of others making their way in the same direction.
34. She came to the pool and found she was not the only one that came to the pool.
35. The other women were sitting close to each other with a strange silence between them.
36. She bounced closer.
37. All of the women looked at her with an unsure expression.
38. And she asks with trepidation in her voice: "all of you? Did the new, strange, unbeknown thing happen to all of you?"
39. And they all nodded, confirming her question.
40. And she said to all of them: "well I am not sure if this is the
unbeknown thing of which he that loves all of us spoke or if this is just the start of this
unbeknown thing, but for me it feels like just the start."
41. So she sat with all of them softly sharing their stories, not in shame but in the uncertainty, that surrounds what happened.
42. It was strange too Flossy to hear the stories because they were all very similar.

10. THE GROWING OF THE UNKNOWN

1. Once the men awoke they joined their partners at the pool as was normal for any day.
2. But this day was different because all the women were there first.
3. The men kept everything to themselves.
4. They all knew of this thing that happened because they listened to everybody whispering about their first time.
5. As time passed on the plain, things returned to a sort of normal.
6. The men became aware that the women were getting larger.
7. This did not worry them as it meant that the women were eating well, they were eating enough for both of them.
8. The men also noticed that the women were starting to behave differently.
9. The men could not explain some of the new behaviour that the women showed.
10. But all this meant was that the men were spending more time playing with each other, without the women.
11. The women could not

and did not want to explain what was going on when asked by their men, particularly when the women were doing something strange.
12. Some of these strange things included but was not limited to,
13. Complaining about the weather when the weather was fine,
14. Ask their man to find them a cabbage and lemon before the sun rose or other strange combinations of food and in some cases food and insects,
15. When strange combinations were found by the man in question the woman in question not wanting the food,
16. The woman complaining about their weight despite the fact that they ate well,
17. Complaining about swollen ankles, knees, feet and various other body parts.

11. THE ARRIVAL

1. And the hamsters were first.
2. Sixteen days and sixteen nights after the night that nobody could explain.
3. A hamster who everybody called Fluffy came to the pool in the morning alone.
4. Everybody saw the expression on his face and was unsure what it meant.
5. Floppy went too Fluffy and ask: "what is it dear friend what is wrong and where is Buffy?"
6. Fluffy looks at floppy, he takes a drink of water, looks back at Floppy and runs back to the nest.
7. Everybody was disturbed by his behaviour and quietly went back to getting food.
8. Flossy's curiosity was getting the better of her and she wandered closer too Fluffy and Buffy's nest.
9. Fluffy came running out in a panic.
10. He looks at Flossy and says to her in confusion: "did you see one there were thirteen and now there are only twelve, did you see it?"
11. Flossy very unsure of

Book of the Dead Bunny
Book of the Begotten

what is going on just looked at Fluffy as he ran back inside the hole.

12. Flossy not sure what was going on and not wanting to be caught up in whatever this was, slowly and
quietly started hopping away.

13. Suddenly Fluffy came running out and looked at Flossy with the biggest look of panic on his face.

14. Fluffy looks at Flossy and says: "they are gone, all of them, all thirteen of them what should I do?"

15. He keeps on looking at her for a long time with fear in his eyes and then he suddenly ran back into his nest.

16. Flossy was getting scared and she backed away from the entrance too Fluffy and Buffy's nest.

17. As she was walking backwards she heard Fluffy shouting with relief: "its ok they were in Buffy's cheeks!"

18. She went hopping as fast as she can back to the rest of the critters.

19. They were all sitting around the pool and softly talking about the facial e xpression Fluffy sported when running around.

20. Floppsy saw Flossy bouncing back at a speed and caught her in his arms.

21. He asked her: "what is going on?"

22. Flossy out of breath and after sometime turned to everyone and told what she saw and heard outside Fluffy and Buffy's nest.

23. Everybody listened with amazement and fear growing in their hearts.

24. After Flossy's story Floppsy turned to everyone and said: "tomorrow morning everybody stay inside. I will meet with Fluffy when he comes to drink water and I will get to the truth of what has happened."

25. Everybody agreed without hesitation.

26. Floppsy carried on saying: "let us not allow our brains to make up stories of what is going on, let us go home and get some sleep"

27. One of the others started saying: "do you think this…"

28. Floppsy interrupted fast: "no I do not think so, we know that thinking is becoming dangerous, so let us not think, we need to go to sleep and rest because we do not know what the truth is or what is going to

Book of the Dead Bunny
Book of the Begotten

happen tomorrow."
29. And with these words everybody went to the places where they sleep without a word.
30. Flossy understood the weight that Floppsy felt with the possibility of the unknowing being here and him taking the responsibility to find out what is going on.
31. So she did not say a word and they went to sleep.
32. The next morning with the breaking of dawn Flossy woke up and she knew Floppsy was gone.
33. And she waited.
34. Floppsy was waiting at the pool not sure if he will see Fluffy and if there is an explanation for his actions.
35. He hoped there was a reasonable explanation, something like hunger or eating a funny new berry or something, he even hoped, wished that Fluffy and Buffy were playing a joke on the rest of the critter.
36. As the sun rose a little bit more, Floppsy saw Fluffy come closer and closer to the pool.
37. Floppsy saw that Fluffy was walking a little strange.
38. Floppsy waited and watched from behind a bush next to the water. He saw that Fluffy was missing three fingers and a piece of his ear.
39. Floppsy was shocked, nothing like this has ever happened.
40. Floppsy was getting very worried.
41. Floppsy waited until Fluffy finished drinking some water.
42. Floppsy moved out from behind the bush and cleared his throat.
43. Fluffy turned to him and said: "good morning Floppsy"
44. Floppsy returned the greeting but before he could carry on with a question.
45. Fluffy said: "you have no idea what is waiting for all of you, well I hope you don't and that it will not be as the thing that has happened to me."
46. Floppsy wanted to say something but Fluffy carried on:
47. "The panics of seeing the thirteen little things come from Buffy and then all of them disappearing.
48. And then my fingers and ear, gone."
49. Fluffy showing his hand with the missing fingers and touch his ear.
50. "Buffy said I was irritating her so she had to calm me down

Book of the Dead Bunny
Book of the Begotten

before I become a danger to the little things."

51. Fluffy could see the confusion and worry in floppy's eyes.

52. He shrugged his shoulders and said to Floppsy: "I have to go before I irritate Buffy again, she said she was being kind and it could have been worse if I was really irritating her."

53. As he started back Floppsy asked: "what little things? You have to tell me please!"

54. Flossy turned to Floppsy and said: "I am not sure but they are there and I know they are mine, I am not even sure what that means, they are, well, I think they are eating Buffy, no, that is not right they are eating from Buffy.

55. She does not mind I think; she is not in pain that I know…"

56. Fluffy went back to his nest.

57. Floppsy was disturbed by this meeting and the explanation.

58. He waited there for the rest to arrive.

59. When they were all there, he told them of his meeting with Fluffy.

60. They were all silenced by his tale.

61. They all quietly went their separate ways to think about the things that Floppsy had told them.

62. The next day Freddy and Gloria the mice were absent from the morning meeting.

63. Everybody was very aware of the two being absent.

64. The fear that was growing amongst them kept everybody quiet and subdued.

65. Flossy not being able to understand or come to terms with this quietly made her way Freddy and Gloria's little hole.

66. When she came to the hole she whispered into the hole: "are you there? Are you ok? We are worried please tell me if you are well?"

67. From the hole came Freddy's voice: "shhhh please. Oh, please, be quiet, they are all asleep and if you wake up Gloria I am afraid the same thing that happened to Fluffy will happen to me."

68. She was shocked to hear these words coming from Freddy and then she asked as quiet as a mouse: "how many came?"

69. Freddy's angry voice came from the darkness of their hole: "twelve, now go please."

70. She went back to the rest

Book of the Dead Bunny
Book of the Begotten

and reported the news to the quiet group.

71. And the group did not know what to say or do.

72. Fluffy was as scared as can be and nobody actually wanted to bump into him just in case there was more of him missing or if it was a madness that befell him.

73. Everybody tried to carry on as if nothing was wrong.

74. The days went by slowly, filled with an unspoken fear and dread.

75. A week after Fluffy and Buffy disappeared the group met at the pool. They heard little squeals coming from Fluffy and Buffy's nest.

76. Everybody stood still and listened.

77. Flossy could not keep her curiosity at bay.

78. Flossy came very close to the nest and peeked around a bush.

79. And she saw thirteen little things crawling around the hole with Fluffy and Buffy keeping watch.

80. She felt a fearful joy welling up in her but she did not know why and she did not dare go any closer or make them aware of her presence.

81. She was afraid that Buffy might turn on her.

82. So she slowly and quietly went back to the rest.

83. She told the rest of what she saw.

84. As soon as she finished her report, everybody was quiet and started leaving the group until it was only Floppsy and Flossy left.

85. And they went home.

86. It was twenty-nine days after the night that started the strange things.

87. The next morning Floppsy and Flossy did not arrive at the morning meeting.

88. And fear grabbed everybody more than ever, if something happened to the two that he loves the most, then what.

89. All of the once they heard Floppsy's voice: "it is nothing to fear there is ten new bunnies with me and Flossy."

Book of the Dead Bunny
Book of the Begotten

3. BEGETTING AND THE BEGOTTEN

1. THE FIRST TWO AND THOSE THAT FOLLOWED

`1. The first two was Floppsy and Flossy, they were in close relationship with the Great Bunny.
2. Through the gift of the Great Bunny they were able to reproduce.
3. They begot ten kids in the first begetting.
4. From the first litter they were called, BigEars, Boo Boo, Ziggy, Whinny, Wiggles, Vinny, Twinky, Tuddy, Spunky and Booby.
5. In a dream the commandment came from the Great Bunny that the litter should wait before mating.
6. BigEars and Booby did not listen to the warning.
7. BigEars and Booby begot a litter of deaf, dumb and blind kids.
8. BigEars, Booby and their litter were thrown out of the family into the woods.
9. They were never heard of again.
10. With the turning of the seasons after the big sleepy the bunnies found a new group of bunnies entering the plain.
11. The first litter took partners from the new group.
12. Boo Boo took Smokey from the visiting group.
13. Ziggy took Lilly from the visiting group.
14. Whinny took Fluffy from the visiting group.
15. Spunky took Binky from the visiting group.
16. Wiggles took Dusty from the visiting group.
17. Vinny, Twinky and Tuddy did not select from the visiting group.
18. They did not find appropriate mates.
19. The first group was permitted to stay for the passing of the season.
20. After waking up from the sleepy it was time for the first group to move to their own place.
21. When the group was ready to depart one of the group went to Floppsy early in the morning and said to him:
22. "After the sleepy a bunny came to me in my head and told me to remind you, not to forget about the Great Bunny."
23. Floppsy turned to a

Book of the Dead Bunny
Book of the Begotten

bunny who was called Cudburry and asked him what he knew about the Great Bunny?

24. Cudburry told Floppsy of the dreams he had during the sleepy.

25. Cudburry told Flossy the following:

26. "The Great Bunny told me to remind you not to forget him who loves you the most.

27. He spoke of the awakening of many enemies that will come to hunt and kill us and our kind.

28. The Great Bunny told me of a time and place where he stops
Being the Great Bunny and becomes the great dead bunny."

29. Floppsy looked at Cudburry and told him that he had to think about his words since they disturbed him greatly.

30. Floppsy asked Cudburry and the group to stay another turning of the seasons.

31. Floppsy went too Flossy and spoke to her of Cudburry's word.

32. Floppsy and Flossy discussed these words at length.

33. They decided that keeping the group for another turning of the
Seasons was a good idea.

34. For both of them the most disturbing thing was the Great Bunny becoming the Great Dead Bunny.

35. They called Cudburry to meet them at the pool and asked him to describe the dream in more detail again and asked for an explanation.

36. Cudburry told both of them the dream in detail.

37. His description of the Great Bunny was true to how Floppsy and Flossy knew the Great Bunny.

38. But the death of the Great Bunny disturbed them.

39. They asked Cudburry to stay with their family from this day on and to tell them of any other dreams.

40. Cudburry agreed.

41. In this season a new group of bunnies arrived on the plain.

42. As with the first group, the rest of the first litter took another bunny.

43. Vinny took Bambi from the
Second group of visiting bunnies.

44. Twinky took Harley from the second group of visiting bunnies.

45. Tuddy took Rosie from the

Book of the Dead Bunny
Book of the Begotten

Second group of visiting bunnies.
46. Floppsy and Flossy decided that all was good with their litter and begot another litter.
47. There second litter gave them twelve kids.
48. The kids were called Brownie, Brownie, Gracie, Marley, Snowy, Teddy, Toddy, Trixie, Penny' Snoopy, Harry and Pippin.
49. When the time was right most of the begotten from the second litter took bunnies from the first and second groups.
50. Brownie took Cudburry from the first group of visiting bunnies.
51. This made Floppsy and Flossy very happy.
52. Brownie took Bugsy from the second group of visiting bunnies.
53. Snowy took Buttons from the second group of visiting bunnies.
54. Teddy took Miffy from the first group of visiting bunnies.
55. Trixie took Snowflake from the second group of visiting bunnies.
56. Snoopy took Toffee from the first group of visiting bunnies.
57. Harry took Cupcake from the second group of visiting bunnies.
58. Marley, Toddy and Pippin did not select bunnies from the first and second group of visiting bunnies.
59. They did not find appropriate mates.
60. Shortly after the arrival of Floppsy and Flossy's second litter Boo Boo and smoky had their first litter.
61. The kids were called BigEars, after Boo Boo's brother that did not listen, Fiona, Gus, Cotton, Monty, Rufus, Floppsy named after his grandfather, and Nutmeg.
62. From this group it seemed that BigEars carried a curse as BigEars was of low intelligence and of even lower instinct.
63. With the arrival of Boo Boo and Smokey's litter a new group of bunnies arrived on the plain.
64. On the same day it was assumed Penny was the first to be taken by one of the bunnies' new enemies.
65. Penny loved bouncing close to the forest that surrounds the plain.
66. Penny was taken by a hawk early one morning.
67. Everybody saw this as Penny was playing on the plain,

Book of the Dead Bunny
Book of the Begotten

when all were gathered in the morning at the pool.

68. The taking of Penny was for Floppsy and Flossy the making flesh of Cudburry's words.

69. Gracie took Bubbles from the third group.

70. Marley took Mopsy from the third group.

71. Pippin took Hoppy from the third group.

72. Ziggy and Lilly's first litter arrived.

73. The kids were called Rupert, Velvet, Honey, Roger, Barney, Mopsy and Flossy named after her Grandmother.

74. When Boo Boo and Smokey's litter was ready they took members from the visiting groups.

75. BigEars took Bambam from the first group. Bambam was known to be a kind and giving bunny but BigEars was slow of comprehension.

76. All the bunnies thought that this would be a match to benefit BigEars.

77. Within a couple of days Bambam complained about BigEars having an insatiable need to make small bunnies all the time.

78. In response to this Boo Boo suggested that Bambam goes to the pool and if BigEars becomes a problem that she should reach between her legs and she should make as if she throws her bunny making parts in to the pool.

79. The next day BigEars became a problem in front of all the other bunnies.

80. Bambam did as she was instructed by Boo Boo.

81. BigEars in a state of shock and surprise jumped into the pool after what he thought was the bunny making parts and drowned.

82. Bambam stayed in the family but never took another bunny.

83. Bambam was instrumental in raising many little bunnies.

84. Fiona took beans from the second group.

85. Cotton took BigWig from the first group.

86. All the bunnies were very surprised by this match, as nobody liked BigWig, not even his brother Biggy.

87. Cotton always seemed to be of good and gentle demeanour.

88. BigWig always thought he knew best and most.

Book of the Dead Bunny
Book of the Begotten

89. BigWig after taking Cotton challenged Floppsy to lead the family.
90. They fought and BigWig ran away with part of one ear missing.
91. That night Floppsy went to Cotton and BigWig in the burrow.
92. He found BigWig tied down and Cotton pushing thorns into his body and nibbling his hurt ear.
93. BigWig was crying in pain but it seemed as if he enjoyed the pain just a bit too much.
94. Floppsy turned around and went back too Flossy.
95. Rufus took Biscuit from the third group.
96. Flossy did not make a selection from the three groups of visiting bunnies.
97. She did not find an appropriate mate.
98. Gus and Monty were taken by two hawks, one being the same hawk that took Penny that same season.
99. They were racing against each other to try and impress sunshine from the third group when the hawks swooped down and took both at the same time.
100. Nutmeg in the early summer went to the edge of the forest that surrounded the plain and disappeared.
101. Nobody knew if she left or was taken by an enemy.
102. Ziggy and Lilly's litter also selected bunnies.
103. Rupert took Blackie from the second group.
104. Velvet took Blitz from the third group of visiting bunnies.
105. Honey took Bouncer from the third group of visiting bunnies.
106. Barney took Didi from the third group of visiting bunnies.
107. Mopsy took Bucky from the third group of visiting bunnies.
108. Floppsy named after his grandfather took FooFoo from the third group of visiting bunnies.
109. Roger wanted to take Bambam but she would not have him.
110. In sorrow Roger went to the edge of the wood and waited for the enemy that took Nutmeg.
111. He sat there waiting until he died of hunger and sorrow.
112. Whinny and Fluffy brought forth their first litter they had six kids.
113. The kids were Bullwinkle,

Book of the Dead Bunny
Book of the Begotten

Lulu, Missy, Butters, Candy and Rusty.
114. Cudburry and Floppsy became very close friends.
115. The two of them would meet every morning at the break of dawn and have a discussion on the possibility of the Great Bunny becoming the great dead bunny.
116. It was to Floppsy and Flossy's great joy that Brownie and Cudburry brought forth their first litter.
117. Brownie and Cudburry had seven kids.
118. They were named Pipkin, Dipsy, Dolly, Dinky, Scully, Silky and Fanny.
119. Shortly after Brownie and Bugsy brought forth their first litter.
120. Brownie and Bugsy had five kids.
121. The kids were named Lilly, Dewy, Zoey, Yoyo, Woody, Puffy and Corky.
122. The next day Snowy and Buttons brought forth their first litter.
123. Snowy and Buttons had six kids.
124. The kids were named Kelly, Wally, Popsey, Podsey, Trudy and JayJay.
125. Two days later Spunky and Binky brought forth their first litter.
126. Spunky and Binky had twelve kids.
127. The kids were named: Jelly, Belly, Charity, Pappy, Pansy, Scotty, Maizy, Mazy, Scooby, Ely, Maddy and Lucky.
128. The next day Teddy and Miffy brought forth their first litter.
129. Teddy and Miffy had eight kids.
130. The kids were named: Rigby, Rikky, Ripley, Risky, Riddy, Riley, Rimy and Rocky.
131. All the bunnies thought that it was cruel of Teddy to insist to call all his kids names that start with the
Letter r, because Miffy could not say the letter r.
132. This meant that the kids were called Igby, Ikky, Ipley, Isky, Iddy, Iley, Rmy and Ocky.
133. This lead to the other kids making fun of these kids.
134. Floppsy, Flossy, Brownie and Cudburry spent hours and hours talking to the kids, both the affected kids and the others.
135. The talks to the affected help most of them but some of them carried the hurt and pain with them.
136. Teddy thought this was very funny until Miffy refused

Book of the Dead Bunny
Book of the Begotten

him more litters.
137. Shortly after Teddy and Miffy brought forth their first litter, Tuddy and Rosie brought forth their first litter.
138. Tuddy and Rosie had six kids.
139. The kids were named Licky, Zesty, Derby, Leary, Randy and Ramsey.
140. The next day Trixie and Snowflake brought forth their first litter.
141. Trixie and Snowflake had eight kids.
142. The kids were named Kory, Cutie, Prudy, Witty, Rudy, Lacy, Lady and Mamy.
143. Shortly after the bringing forth their litter Twinky and Harley brought forth their first litter.
144. Twinky and Harley had ten kids.
145. The kids were named Lindy, Abby, Dilly, Dipsy, Coney, Donny, Rolley, Dotty, Ally and Loopy.
146. Pippin and Hoppy brought forth their first litter.
147. Pippin and Hoppy had five kids.
148. The kids were named Lizzy, Dumpty, Rumy, Eddy and Sassy.
149. Shortly after Harry and Cupcake brought forth their first litter.
150. Harry and Cupcake had ten kids.
151. The kids were named Elvis, Magoo, Eclair, Archie, Saro, Satin, Lotto, Lotus, Roto and Ash.
152. Later on the same day Gracie and Bubbles brought forth their first litter.
153. Gracie and Bubbles had six kids.
154. The kids were named Marley, Misty, Maxy, Fancy, Beefy and Fluffy.
155. Shortly after Marley and Mopsy brought forth their first litter.
156. Marley and Mopsy had seven kids.
157. The kids were named Milly, Flotty, Smokey, Fomsey, Gibby, Spinny and Gordy.
158. Shortly after Snoopy and Toffee brought forth their first litter.
159. Snoopy and Toffee had seven kids.
160. The kids were named Ginny, Bonny, Brinkley, Sunny, Peachy, Tabby and Teddy.
161. Shortly after Wiggles and Dusty brought forth their first

Book of the Dead Bunny
Book of the Begotten

litter.
162. Wiggles and Dusty had five kids.
163. The kids were named Busby, Nippy, Osy, Ozzy and Iggy.
164. Shortly after Vinny and Bambi brought forth their first litter.
165. Vinny and Bambi had twelve kids.
166. The kids were named Aggie, Linnie, Rinnie, Dookie, Sadie, Maggie, Emmie, Minnie, Biffie, Moonie, Hattie and Flattie.
167. Shortly after Toddy and Cuddels brought forth their first litter.
168. Toddy and Cuddles had nine kids.
169. The kids were named Mikkie, Nikkie, Hoochie, Hoppy, Indie,
Cherry, Peggy, Perky and Tully.
170. After BigEars and Booby it was believed that no brother and
sister should mate as the Great Bunny commanded.
171. It was with great enthusiasm that the family continued to receive new groups of visiting bunnies.
172. It was agreed that this was a good rule to have.
173. To ensure that this rule was followed by those that were yet to come kids had to be known by their mother and father.
174. This rule could only be waived
175. If a new group of bunnies visited and the visiting group did not know of the rule.
176. Bullwinkle, son of Winny and Fluffy, chose Sassy, daughter of Pippin and Hoppy.
177. Lulu, daughter of Whinny and Fluffy, chose Marley, son of Bubbles and Grace.
178. Missy, daughter of Winny and Fluffy, chose Mikkie, son of Toddy and Cuddles.
179. Butters, son of Whinny and Fluffy, chose Belly, daughter Spunky and Binky.
180. Candy, daughter of Whinny and Fluffy, chose Pappy, son of Spunky and Binky.
181. Rusty, son of Whinny and Fluffy, chose Busby, daughter of Wiggles and Dusty.
182. Jelly, son of Spunky and Binky, chose Slinky, daughter of Brownie and Cudburry.
183. Charity, daughter Spunky and Binky, chose Flattie, son of Vinnie and Bambi.
184. Pansy, son of Spunky and Binky, chose Randy, daughter of Tuddy and Rosie.
185. Scotty, son of Spunky and Binky, chose Licky, daughter of

Book of the Dead Bunny
Book of the Begotten

Tuddy and Rosie.

186. Maizy, daughter of Spunky and Binky, chose Dookie, son of Vinny and Bambi.

187. Mazy, daughter of Spunky and Binky, chose Maxy, son of Gracie and Bubbles.

188. Scooby, son of Spunky and Binky, chose Risky daughter of Teddy and Miffy.

189. Ely, daughter of Spunky and Binky, chose Eddy son of Pippin and Hoppy.

190. Maddy, daughter of Spunky and Binky, chose Brinkly, son of Snoopy and Toffee.

191. Lucky, son of Spunky and Binky, chose Smokey, daughter of Marley and Mopsy.

192. Aggie, daughter of Vinnie and Bambi, chose Loopy son of Twinky and Harley.

193. Nippy, son of Wiggles and Dusty, chose Rinnie daughter Vinny and Bambi.

194. Osy, son of Wiggles and Dusty, chose Dipsy daughter of Twinky and Harley.

195. Ozzy, son of Wiggles and Dusty chose Lotus daughter of Harry and Cupcake.

196. Iggy, son of Wiggles and Dusty chose Lizzy, daughter of Pippin and Hoppy.

197. Linnie, son of Vinny and Bambi chose Hoochie daughter

Toddy and Cuddles.

198. Sadie, son of Vinny and Bambi chose Prudy daughter Trixie and Snowflake.

199. Maggie, daughter of Vinny and Bambi chose Dotty, son of Twinky and Harley.

200. Emmie, daughter of Vinny and Bambi chose Rocky son of Teddy and Miffy.

201. Minnie, daughter of Vinny and Bambi chose Woody, son of Brownie and Bugsy.

202. Biffie, daughter of Vinny and Bambi chose Skully, son of Brownie and Cudburry.

203. Moonie, daughter of Vinny and Bambi chose Dewy son of Brownie and Bugsy.

204. Hattie, son of Vinny and Bambi chose Mamy, daughter of Trixie and Snowflake.

205. Lindy, daughter of Twinky and Harley chose Dumpty son of Pippin and Hoppy.

206. Abby, daughter of Twinky and Harley chose Wally son of Snowy and Buttons.

207. Dilly, daughter Twinky and Harley chose Dipsy, son of Brownie and Cudburry.

208. Coney, daughter of Twinky and Harley chose Elvis, son of Harry and Cupcake.

209. Donny, son of Twinky and Harley chose Leary daughter

Book of the Dead Bunny
Book of the Begotten

of Tuddy and Rosie.

210. Rolly, son of Twinky and Harley chose Fanny daughter of Brownie and Cudburry.

211. Ally, daughter Twinky and Harley chose Kory, son of Trixie and Snowflake.

212. Zesty, daughter of Tuddy and Rosie chose Pipkin, son of Brownie and Cudburry.

213. Derby, son of Tuddy and Rosie chose Cutie daughter of Trixie and Snowflake.

214. Leary, daughter of Tuddy and Rosie chose Puffy, son of Brownie and Bugsy.

215. Ramsey, son of Tuddy and Rosie chose Rumy, daughter Pippin and Hoppy.

216. Dolly, daughter of Brownie and Cudburry chose Rigby son of Teddy and Miffy.

217. Dinky, daughter of Brownie and Cudburry chose Beefy son of Gracie and Bubbles.

218. Lilly, daughter of Brownie and Bugsy chose Gordy, son of Marley and Mopsy.

219. Zoey, daughter of Brownie and Bugsy chose Ripley, son of Teddy and Miffy.

220. Yoyo, son of Brownie and Bugsy chose Lady, daughter of Trixie and Snowflake.

221. Corky, son of Brownie and Bugsy chose Cherry, daughter of Toddy and Cuddles.

222. Kelly, daughter of Snowy and Buttons chose Indie, son of Toddy and Cuddles.

223. Popsey, son of Snowy and Buttons chose Sunny, daughter of Snoopy and Toffee.

224. Popsey, son of Snowy and Buttons chose Rimy daughter Teddy and Miffy.

225. Trudy, daughter of Snowy and Buttons chose Tabby, son of Snoopy and Toffee.

226. JayJay, daughter of Snowy and Buttons chose Teddy son of Snoopy and Toffee.

227. Rikky, son of Teddy and Miffy chose Eclair, daughter of Harry and Cupcake.

228. Riddy, daughter of Teddy and Miffy chose Hoppy, son of Toddy and Cuddles.

229. Riley, son of Teddy and Miffy chose Lotto, son of Harry and Cupcake.

230. Witty, son of Trixie and Snowflake chose Satin, daughter of Harry and Cupcake.

231. Rudy, son of Trixie and Snowflake chose Fluffy, daughter of Gracie and Bubbles.

232. Lacy, daughter of Trixie and Snowflake chose Magoo, son of Harry and Cupcake.

233. Tully, son of Toddy and Cuddles chose Spinny, daughter

Book of the Dead Bunny
Book of the Begotten

of Marley and Mopsy.
234. Perky, son of Toddy and Cuddles chose Flotty, daughter of Marley and Mopsy
235. Peggy, daughter of Toddy and Cuddles chose Archie, son of Harry.
236. Nikkie, daughter of Toddy and Cuddles chose Gibby, son of Marley and Mopsy.
237. Fomsey, daughter of Marley and Mopsy chose Saro, son of Harry and Cupcake
238. Milly, daughter of Marley and Mopsy chose Ash, son of Harry and Cupcake.
239. Fancy, daughter of Gracie and Bubbles chose Roto, son of Harry and Cupcake.
240. Fancy, son of Gracie and Bubbles chose Ginny, daughter of Snoopy and Toffee.
241. Misty, son of Gracie and Bubbles chose Peachy daughter of Snoopy and Toffee.
242. After the choosing all the Bunnies went to separate spots to get to know each other.
243. With all the bunnies busy discussing who chose who and those who chose and those that got chosen getting to know each other.
244. Floppsy and Cudburry sat by the water of the pool in the late summer afternoon.
245. Floppsy asked Cudburry if he had any other dreams.
246. Cudburry said that he had not had any dreams from or of the Great Bunny.
247. And Cudburry said to Floppsy that his first and only dream came during the sleepy.
248. Cudburry carried on and said that it might only be that during a long sleep like the sleepy the mind becomes open to the voice of the Great Bunny.
249. Both of them gave the idea some thought and then carried on talking about the choosing.
250. As summer was winding down and the season was turning too autumn it seemed like a surprise when at the end of summer Fiona and beans brought forth their first litter.
251. Fiona and beans had a litter of eight kids.
252. The kids were called Baba, Nomy, Fiffy, Dalia, Gibsy, Lala, Thunder and Blunder.
253. Everybody was perplexed by the name Blunder but let it be.
254. Floppsy kept quiet about what he saw but he was very amazed when BigWig and Cotton brought forth their first litter.
255. BigWig and Cotton had a litter of twelve kids.

Book of the Dead Bunny
Book of the Begotten

256. The kids were called Wiggles, Blunder, Blunder, NomNom, JoJo, Polly, Jolly, NaNa, Sally, Polly, Solly and Tatty.
257. Within two days Rufus and Biscuit brought forth their first litter.
258. Rufus and Biscuit had a litter of seven kids.
259. And the kids were called Bucky, Ducksy, Kelly, Molly, Bossy, Bushy, Potsy, Bonny and Donny.
260. Shortly after Rupert and Blackie brought forth their first litter.
261. Rupert and Blackie had a litter of ten kids.
262. The kids were called Rossie, Blossom, Kiko, Willow, Swollow, Redsy, Ace, Amino, Astro and Baggins.
263. Shortly after Rupert and Blackie bringing forth, Velvet and Blitz brought forth their first litter.
264. Velvet and Blitz had a litter of nine kits.
265. The kids were called: Gismo, Henry, Hippy, Holly, Jilly, Jolly, Kirby, Linus, Latte and Nalla.
266. Two days after Honey and Bouncer brought forth their first litter.
267. Honey and Bouncer had a litter of eleven kits.
268. The kits were named: Showoff, Silver, Tank, Venus, Zipper, Blu, Cannoli, Diago, Elmer, Ed and Duke.
269. The very next day Barney and Didi presented their first litter.
270. Barney and Didi had a litter of twelve kids.
271. The kids were named: Ernie, Fido, Foxy, Frosty, Fudge, HotLips, Jax, Kitten, Maggie, Marmalade, Angel and Angora.
272. Shortly after Mopsy and Bucky brought forth their first litter.
273. Mopsy and Bucky had a litter of thirteen kids.
274. The kids were named: Dopey, Doris, Allie, Rollin, Loki, Magpie, Eeyore, Santos, Elton, Fella, Maz, Barlow, Barbie and Shady.
275. Shortly after Floppsy and FooFoo brought forth their first litter.
276. Floppsy and FooFoo had a litter of thirteen kids.
277. The kits were named: Banger, Fancy Flash, Bow, Mick, Spanky, Spunky, Flea, Blaise, Sonny, BJ, Moody, Fuzzbutt and Bitty.
278. Shortly after Bullwinkle

Book of the Dead Bunny
Book of the Begotten

and Sassy brought forth their first litter.
279. Bullwinkle and Sassy had a litter of twelve kids.
280. The kids were named: Spaz, Gertie, Bluto, Mopatop, Hedda, Nifty, Tammy, Capri, Oppie, Tiger, Trudy and Paws.
281. Shortly after Missy and Mikkie brought forth their first litter.
282. Missy and Mikkie had a litter of twelve kids.
283. The kids were named: Tritt, Pele, Jaffa, Cher, Katie, Poo, Cola, Lars, Dank, Xane, Radar and Lucia.
284. Shortly after Butters and Belly brought forth their first litter.
285. Butters and Belly had a litter of thirteen kids.
286. The kids were named: Ruffies, Dub, Lucy, Andy, Mandm, Ariel, Basse, Shep, Miffy, Flo, Belle, Simba and Bliss.
287. Shortly after Candy and Pappy brought forth their first litter.
288. Candy and Pappy had eleven kids in the litter.
289. The kids were named: Gandalf, Moonbeam, Blackberry, Sunshine, Nancy, Brummel, Napoleon, Bubbles, Nibbler, Sweetcorn and Buggers.
290. Shortly after Rusty and Busby brought forth their first litter.
291. Rusty and busty had twelve kids in the litter.
292. The kits were named: Nibblets, Noodles, Hippolite, Bunnykin, Nimbus, Oatmeal, Hophazard, Thornberry, Tiggywinkle, Pancake, Cashew and treasure.
293. Shortly after Jelly and Slinky brought forth their first litter.
294. Jelly and Slinky had twelve kids in the litter.
295. The kids were named: Albabster Digger, Lint, Rinnie, Rocky, Dolly, Alfonzo, Dorothy, Earwig, Sammy, Lupin and Scrappy.
296. Shortly after Charity and Flattie brought forth their first litter.
297. Charity and Flattie had twelve kids in the litter.
298. The kits were named: Leopold, Dermot, Ziggy, Deefer, Redbone, Yampa, Rainbow, Wormy, Custard, Quincy, Komokai and Kosmo.
299. The next day Pansy and Randy brought forth their first litter.
300. Pansy and Randy had twelve kids in the litter.

Book of the Dead Bunny
Book of the Begotten

301. The kids were named: Lindsey, Dilly, Abbott, Dixie, Draco, Sambra, Maddy, Edward, Babbit, Balls, Sensen and Maxwell.

302. Shortly after Scotty and Licky brought forth their first litter.

303. Scotty and Licky had a litter of twelve kids.

304. The kids were named: Fabian, Mausi, Banana, Shelbi, Feisty, Barksalot, Barnaby, Flurry, Minky, Smoochie, Gammon and Fuzzette.

305. Shortly after Maizy and Dookie brought forth their first litter.

306. Maizy and Dookie had a litter of twelve kits.

307. The kids were named: Monkey, Sparkles, Blackjack, Fusilli, Bishop, Binkyboy, Moppet, Spookie, Bodkin, Blossom, Gremlin and Mudpie.

308. Shortly after Mazy and Maxy brought forth their first litter.

309. Mazy and Maxy had twelve kids in the litter.

310. The kids were named: Gretchen, Mullberry, Sugerpuff, Whiskers, Potter, Stumper, Bouncy, Hamlet, Swoozie, Tadpole, Buggy and Berry.

311. Shortly after Scoopy and Risky brought forth their first litter.

312. Scoopy and Risky had twelve kids in their litter.

313. The kids were named: Nickelby, Bumper, Thumper, Nimrod, Hershey, Buster, Tempess, Tibbles, Onion, Inkberry, Tomato and Casper.

314. Shortly after Maddy and Brinkly brought forth their first litter.

315. Maddy and Brinkly had twelve kids in the litter.

316. The kids were named: Tokio, Palomino, Chancy, Topsey, Pandora, Isabella, Jabori, Pepper, Tuesday, Jeeves, Chesswood and Peppermint.

317. Shortly after Lucky and Smokey brought forth their first litter.

318. Lucky and Smokey had twelve kids in their litter.

319. The kids were named: Ace, BigBoy, Biscotte, Jessabelle, Cheshire, Tudney, Penelope, Kalecio, Wallaby, Colonel, Cobalt and Kailee.

320. Shortly after Nippy and Rinnie brought forth their first litter.

321. Nippy and Rinnie had twelve kids in the litter.

Book of the Dead Bunny
Book of the Begotten

322. The kids were named: Kellogg, Prancer, Conptessa, Preston, Whoopi, Cottonball, Kibbles, Prissy, Wiggler, Coriander, Laptop and Raisen.

323. Shortly after Osy and Dipsy brought forth their first litter.

324. Osy and Dipsy had a litter of twelve kits.

325. The kids were named: Yankee, Ladybug, Prancer, Daphne, Larissa, Lemondrops, Zambouka, Leland, Lavender, Zoolander, Rerun and Lillibet.

326. And there was a rest.

327. For a couple of days there was quiet in the bringing forth of litters.

328. It was a break that everybody needed because it became an important tradition that all the bunnies came together to meet the new bunnies when they came out of the barrow.

329. For Floppsy and Cudburry the couple of days became a time for them to have their conversations for longer than just the morning before the plain started coming alive with the family of bunnies.

330. Floppsy shared everything he knew and learned from the Great Bunny to Cudburry.

331. And they both discussed Cudburry's dreams.

332. But it never went further than just repeating what was already said.

333. Their discussions after a while started off with a discussion on the Great Bunny and then turned to the family and the plain.

334. From time to time the two quietly discussed the enemy that made their appearance.

335. Floppsy and Cudburry continued their discussions some evenings in the dark of the burrow, when they started keeping a record of the kids and the parents from whom they came as well as some of the other information that they thought would be of value.

Book of the Dead Bunny
Book of the Begotten

2. THE NEW RECORD KEEPING

1. And the season came to a close.
2. All the bunnies went for the great sleepy.
3. Floppsy and Flossy were ready for spring and on the first day of spring the two with Cudburry and Browny went early the morning to the pool with the hope of the Great Bunny waiting for them.
4. They were disappointed.
5. They sat and watched the quiet morning dawn on their plain before the rest woke up.
6. In the great meeting where all the critters met, it became apparent to Floppsy and Cudburry that it was time that some of the visiting groups of bunnies might have to move on.
7. With this in mind Floppsy and Cudburry called a meeting with the leaders of the visiting groups of bunnies to have the discussion.
8. Before they could raise the matter, the leaders started by thanking them for their hospitality and apologise for staying so long but they felt it was time to go.
9. In a big meeting, the announcement was made and a choice was given to all those who became part of Floppsy and Flossy's family whether they would like to stay or go with the visiting groups of bunnies.
10. A period of seven days was given for all to make their choice.
11. After seven days all the families decided to stay, much to Floppsy and Flossy's joy.
12. On the day of the great departure there was a great sadness but all knew it was the right thing to do.
13. Within a week of the great departure another group of bunnies made their appearance.
14. The new group was welcomed as the other groups.
15. And there was joy in the new arrival.
16. Within a couple of days, Floppsy and Flossy noticed that the group worked differently from the way their family worked.
17. The new group was very ordered, they had a distinct hierarchical system.
18. This was strange but Floppsy and Flossy welcomed all bunnies to their plain.
19. The leader of this group

Book of the Dead Bunny
Book of the Begotten

was called Delta, a very strong bunny.
20. Shortly after the arrival of the new group there was another choosing.
21. Bullwinkle, it seems, has found a group that was much like himself but just faster.
22. A couple of days passed and everybody was encouraged to get to know the new group of visiting bunnies.
23. It came to the time for another selection.
24. Rossie, daughter of Rupert and Blackie chose Dingelberry, from the visiting group of bunnies.
25. Blossom, daughter of Rupert and Blackie chose Flafio, from the new tribe of visiting bunnies.
26. Kiko, son of Rupert and Blackie chose Slot, from the visiting bunnies.
27. Willow, daughter of Rupert and Blackie chose Flash, son of Floppsy and FooFoo
28. Swallow, son of Rupert and Blackie chose KooKoo, from the Visiting group of bunnies.
29. Redsy, son of Rupert and Blackie chose Nancy, daughter of Candy and Pappy.
30. Ace, son of Rupert and Blackie chose Yampa, daughter of Charity and Flatty.
31. Amino, daughter of Rupert and Blackie chose Blackjack, son of Maizy and Dookie.
32. Astro, daughter of Rupert and Blackie chose Kellogg, son of Rinnie and Nippy.
33. Baggins, son of Rupert and Blackie chose Ladybug, daughter of Dipsy and Osy.
34. Gizmo, son of Velvet and Blitz chose Onion, daughter of Scooby and Risky.
35. Henry, son of Velvet and Blitz chose Tadpole, daughter Mazy and Maxy.
36. Hippy, daughter of Velvet and Blitz chose Tiger, son of Bullwinkel and Rusty.
37. Holly, and her sister Jilly both wanted to choose Rapsy, form the third visiting group of bunnies.
38. This caused quite the commotion.
39. Now way was seen to resolve the dispute.
40. Everybody looked to Floppsy to resolve the matter.
41. Floppsy decided that it would be wise to send both the girls into the forest for three nights.
42. Whoever returned after three nights would have their

Book of the Dead Bunny
Book of the Begotten

selection recognised by the rest of the bunnies.

43. Jolly, son of Velvet and Blitz chose Jessabelle, daughter of Lucky and Smokey.

44. Latte, son of Velvet and Blitz chose Barbie, daughter of Mopsy and Bucky.

45. Nalla, daughter of Velvet and Blitz chose Wormy, son of Charity and flatty.

46. Showoff, son of Honey and Bouncer chose Lucy, daughter of Butters and Belly.

47. Silver, son of Honey and Bouncer chose BJ, daughter of Floppsy and FooFoo.

48. Tank, son of Honey and Bouncer chose Bliss, daughter of Butters and Belly.

49. Venus, daughter of Honey and Bouncer chose Brummel, son of Candy and Pappy.

50. Zipper, daughter of Honey and Bouncer chose Bunnykin, son off Rusty and busty.

51. It was getting late and as the kids made their choice they were free to go but Floppsy and Flossy had to stay and recognise the new couple.

52. Floppsy and Flossy was tired and called an end to the day's selection.

53. Everybody was disappointed because they wanted to get to their chosen.

54. Those who were chosen were more interested in who would select them.

55. This made them even more desperate to have the curiosity satisfied.

56. As Floppsy and Flossy bounced to their spot on the bank of the pool, Floppsy saw Delta and called him over.

57. Floppsy's discussed the decision regarding Holly and Jilly with Delta.

58. While in mid-discussion Delta stopped him and simply said: "why not let Rapsy make his decision? Or let him have both?"

59. Floppsy was taken aback by Delta being so forward and replied: "we do not work like that."

60. Delta said: "well you then killed two bunnies for no real reason."

61. Delta bounced away.

62. Floppsy, very troubled by the signs of disrespect, let the matter go and joined Flossy as they went into their warren.

63. It was a troubled night and Floppsy could not sleep.

64. He laid very still in their nest wondering how Holly and Jilly were doing.

Book of the Dead Bunny
Book of the Begotten

65. As morning came Floppsy was still tired but had to go on with the selection that would start as soon as everybody arrived in the morning.
66. Flossy and Floppsy met the rest of the group next to the pool.
67. As a silence came over Everybody Flossy indicated that it should start.
68. And so it did.
69. Blu, daughter of Honey and Bouncer chose buggers, son of Candy and Pappy.
70. Cannoli, daughter of Honey and Bouncer chose Mullberry, son of Mazy and Max.
71. Diago, son of Honey and Bouncer chose Belle, daughter of Butters and bell.
72. Elmer, son of Honey and Bouncer chose crystal, from the third group of bunnies.
73. Ed, son of Honey and Bouncer chose Edna, from the third group of bunnies.
74. Ernie, son of Barney and Didi chose Miffy, daughter of Butters and Bell.
75. Fido, son of Barny and Didi chose Tritt, daughter of Missy and Mikkie.
76. Foxy, daughter of Barny and Didi chose Pancake, son of Rusty and busty.
77. Frosty, daughter of Barney and Didi chose Spooky, son of Maizy and Dookie.
78. Fudge, son of Barney and Didi chose Mand, daughter of Butter and Belly
79. HotLips, daughter of Barney and Didi chose Yankee, son of Dipsy and Osy.
80. Jax, daughter of Barney and Didi chose Kibbles, son of Rinnie and Nippy.
81. Kitten, daughter of Barney and Didi chose Delta, for the third group of bunnies.
82. And there was silence Waiting to see the reaction from Floppsy, Flossy and Delta.
83. Nobody was sure what the Outcome would be.
84. Floppsy waited to see what Delta would do.
85. Delta walked up and took Kitten as the one who selected him.
86. Floppsy gave the signal in Accepting the union.
87. He waved for the next selection to take place.
88. Maggie, daughter of Barney and Didi chose Nibblets, son of Rusty and Bust.
89. Marmalade, daughter of Barney and Didi chose gammon, son of Scotty and Licky
90. And it was the midday

Book of the Dead Bunny
Book of the Begotten

break.

91. Floppsy immediately went to the edge of the pool and he sat there waiting for the rest to start.

92. Flossy remained seated and watched Floppsy.

93. After a while Flossy went to Floppsy and asked if he was comfortable.

94. No further words exchanged for a while.

95. Eventually Floppsy said to Flossy: "where is the Great Bunny?"

96. And there was nothing further.

97. Floppsy and Flossy watched the sun glimmer in the pool reflecting their beloved tree.

98. And then the selection started again and the two re-joined the proceedings.

99. Dopey, son of Mopsy and Bucky chose moppet, daughter of Maizy and Dookie.

100. Doris, daughter of Mopsy and Bucky chose Albabster, son of Jelly and Slinky.

101. Allie, daughter of Mopsy and Bucky chose Duke, son of Honey and Bouncer.

102. Rollin, son of Mopsy and Bucy chose Peepoo, from the visiting group of bunnies.

103. Magpie, daughter of Mopsy and Bucky chose Kirby, son of Honey and Bouncer.

104. Eeyore, son of Mopsy and Bucky chose RainBow, daughter of Charity and Flatty.

105. Santos, son of Mopsy and Bucky chose Fuzzette, daughter of Scotty and Licky.

106. Elton, son of Mopsy and Bucky chose rerun, daughter of Dipsy and Osy.

107. Fella, son of Mopsy and Bucky chose Capri, daughter of Bullwinkle and Sassy.

108. Maz, daughter of Mopsy and buck chose napoleon, son of Candy and Pappy.

Book of the Dead Bunny
Book of the Begotten

3. THE NEW CHALLENGE

1. Banger, son of Floppsy and FooFoo chose Bitty his own sister.
2. And there was silence.

Book of the Dead Bunny
Book of the Begotten

3. Floppsy looked at the couple and commanded them to go to the forest and never return.
4. Both of them looked at each other and they left.
5. Delta came forward and demanded to know why this union was not permitted on the plain.
6. There was silence.

7. Floppsy turned to Delta and said: "we might be family now but I am sitting in the place that has seen what might happen and there is no place for that in our home."

Book of the Dead Bunny
Book of the Begotten

8. Floppsy carried on: "Delta if you chose to question my decisions then please stand before me and make your challenge. I sit here because of the one that loves us the most…
9. I only follow the word of the Great Bunny."

4. THE NEW CHALLENGE AGAIN

1. Delta stood before Floppsy and said: "maybe it is time for change but it is not my place to question you're believe in this Great Bunny…"
2. And there was silence.

Book of the Dead Bunny
Book of the Begotten

ubordinates will be known as Smallballs."
6.	Delta looked at Floppsy and as he wanted to say something Kitten laid her hand on his arm and told him that he had gone far enough.
7.	Smallballs looked at Kitten and said: "we will see!"
8.	And that was the end of the day.

3.	Floppsy came closer to Delta and asked: "is this your challenge?"
4.	Delta backed away and whispered so everybody could hear: "not yet".
5.	Floppsy turned to the rest of the gathering and said: "this is the end of the day. It seems as if Delta does not want to make a direct challenge and therefore is the one who criticise, so from now on Delta's family and my s

Book of the Dead Bunny
Book of the Begotten

5. THE NEW DREAM

1. Floppsy and Flossy went straight to their sleeping place and stayed there.
2. There was quite a murmuring about the challenge and some collected around the pool talking about Smallballs challenge and his failure.
3. And some gathered around a tree and spoke about the interesting things Delta spoke of.
4. That night in the dark of their hole, Floppsy and Flossy sat quietly.
5. Both of then thinking of their happy times with the Great Bunny.
6. Both wondering why he left them and both remembering the words Cudburry spoke to them of his dream.
7. They were both close to tears in their silence.
8. Suddenly there was a knocking at their door.
9. Flossy went to open the door.
10. Cudburry was standing there with Brownie.
11. Floppsy told them that it was not a good time to visit they were both feeling sad.
12. Cudburry said: "I know how you feel and we feel the same but you have to hear my words."
13. Floppsy tried to protest and firmly told them: "no we don't need to hear any more words, we want to rest for tomorrow's choosing."
14. Floppsy tried to close the door by force.
15. Brownie stopped her and said: "please don't. This is important. It is not just one dream but the same dream for both of us, you have to listen!"
16. Flossy, with very little energy left in her body after the day, opened the door to let them in.
17. The four of them sat in the dark with the door closed.
18. Floppsy, very tired, told them to tell him and Flossy of their dream and to hurry up.
19. Cudburry started: "after the events of today both me and Brownie went straight to bed and fell asleep as our heads were down.
20. And we dreamt the Great Bunny standing before us with radiant light shining from him.
21. We took each other's hand and stood there too afraid to say anything."
22. Floppsy growing inpatient

Book of the Dead Bunny
Book of the Begotten

insisted that they carry on.
23. Brownie carried on: "we stood there not sure what to do and then the Great Bunny told us that everything that has happened is according to his plan, but we need to be aware of the next part of the events.
24. On the third day of the choosing Smallballs will challenge Floppsy.
25. Floppsy should not accept the challenge but rather let the bunnies chose who they want as leader and they should stand behind their chosen leader.
26. Smallballs will want to fight and will attack Floppsy.
27. Floppsy should allow him to.
28. Brownie stopped and looked at Cudburry.
29. Floppsy and Flossy stood there in silence and shock.
30. Cudburry carried on: "Floppsy should not fight back as the outcome has already been set."
31. Cudburry carried on: "there will be bunnies that stop the fight and with Smallballs holding tight his
Anger, he will crawl away and his pride will take over.
32. Smallballs will agree to this the last choosing.
33. But he will insist that the one with the least number of bunnies will have to Bow to the rule of the new leader.
34. Floppsy must not agree. Floppsy must just carry on."
35. Floppsy and Flossy having heard these words felt some joy return to their tired bodies and a bit of light return to their minds.
36. Floppsy then asked in a way that sounded like a statement: "and then Smallballs will know that I am the leader because more bunnies will stand behind me."
37. Brownie and Cudburry both shook their heads.
38. Floppsy, filled with anger, wanted to explode, shouting and screaming but he kept his temper at bay and asked: "but how can that be? Does the Great Bunny not love us as he used to? What have we done wrong? Where did I go astray?"
39. Flossy started to cry while Flossy and Floppsy were holding each other.
40. Cudburry looked at Floppsy and Flossy and told them the
following: "the Great Bunny said it was all part of the plan, he has chosen this way for us and we have to follow, is that not what

Book of the Dead Bunny
Book of the Begotten

you taught me?"
41. Flossy and Floppsy calmed down and told Cudburry to carry on.
42. Cudburry carried on: "Floppsy would announce the choosing and let the bunnies decide.
43. More bunnies will choose to stands with Smallballs.
44. Floppsy you will ask three times if the bunnies behind you are sure.
45. With every asking more will go to Smallballs side.
46. Once the selection had been completed, Smallballs will insist that you and your followers bow to him, you must not bow to Smallballs."
47. Cudburry stopped and looked at Floppsy.
48. Floppsy told Cudburry to carry on and Cudburry carried on:
49. "Smallballs will insist as this was the arrangement.
50. Floppsy must tell him that it was not.
51. Smallballs will argue but Flossy must not give in.
52. In his anger Smallballs will tell his followers to attack Floppsy and his follower.
53. Floppsy must then run to the sun.
54. That is what I the Great Bunny command."
55. There was silence.

Book of the Dead Bunny
Book of the Begotten

56. After a bit of time passed in the dark.
57. Floppsy holding Flossy tight said: "if this is what the Great Bunny command than that is what we will do."
58. There was silence again.

Book of the Dead Bunny
Book of the Begotten

59. Brownie said quietly: "we are to stand with you, the Great Bunny commanded and we will."
60. In the silence Cudburry and Brownie left Floppsy and Flossy.

6. AFTER THE DREAM REVEALED AND THE CHALLENGE

1. The next morning everybody gathered for the choosing of partners.
2. But there was a heaviness in the air.
3. Flossy started by asking if either Holly or Jilly has returned to claim Rapsy.
4. Nobody could answer.
5. Floppsy left the question unanswered and indicated that the choosing should continue.
6. Smallballs came forward and stood in front of Floppsy.
7. There was a quiet tension amongst the other bunnies.
8. Everybody paid careful attention.
9. Floppsy asked: "Smallballs, what can we do for you? You have been selected and you cannot select another. Those are the rules."
10. Smallballs said: "Smallballs is not my name, I am Delta and I am here to challenge you and your belief. You are not right for this group any more than I am…."
11. Floppsy interrupted: "there will not be a challenge."
12. Smallballs wanted to start screaming that he had the right to challenge but Floppsy said: "we will let the bunnies decide who they want to be the leader."
13. Smallballs in a fit of anger attacked Floppsy.
14. Floppsy just stood there.
15. Smallballs scratched Floppsy's eye and it started bleeding.
16. Cudburry and a couple of other bunnies restrained Smallballs.
17. Smallballs fought against the bunnies holding him back.
18. Eventually calm was restored and Smallballs agreed to the choosing of a leader.
19. Before the choosing started Smallballs said to everybody: "the one with the most bunnies will be the new leader and the looser will Bow to the new leader."
20. Smallballs waited for a reply and there was none.
21. He shouted his demand again and everybody could see his temper returning.
22. Out of the crowd of bunnies Brownie shouted: "let us choose, let us choose let us choose, let us choose, let us choose, lets choose let us choose, let us choose, let us choose, lets choose let us choose, let us

Book of the Dead Bunny
Book of the Begotten

choose, let us choose, lets choose
let us choose, let us choose,
let us choose, lets choose let
us choose, let us choose, let us
choose, lets choose let us choose,
let us choose, let us choose,
lets choose let us choose, let us
choose, let us choose, lets choose
let us choose, let us choose,
let us choose, lets choose let
us choose, let us choose, let us
choose, lets choose let us choose,
let us choose, let us choose,
lets choose let us choose, let us
choose, let us choose, lets choose
let us choose, let us choose let us
choose, lets choose let us choose,
let us choose, let us choose,
lets choose let us choose, let us
choose, let us choose, lets choose
let us choose, let us choose.et us
choose, let us choose, lets choose
let us choose, let us choose, let us
choose, lets choose let us choose,
let us choose, let us choose,
lets choose let us choose, let us
choose, let us choose, lets choose
let us choose, let us choose let us
choose, lets choose let us choose,
let us choose, let us choose,
lets choose let us choose, let us
choose, let us choose, lets choose
let us choose, let us choose.et us
choose, let us choose, lets choose
let us choose, let us choose, let us
choose, lets choose let us choose,

let us choose, let us choose,
lets choose let us choose, let us
choose, let us choose, lets choose
let us choose, let us choose let us
choose, lets choose let us choose,
let us choose, let us choose,
lets choose let us choose, let us
choose, let us choose, lets choose
let us choose, let us choose.et us
choose, let us choose, lets choose
let us choose, let us choose, let us
choose, lets choose let us choose,
let us choose, let us choose,
lets choose let us choose, let us
choose, let us choose, lets choose
let us choose, let us choose let us
choose, lets choose let us choose,
let us choose, let us choose,
lets choose let us choose, let us
choose, let us choose, lets choose
let us choose, let us choose.et us
choose, let us choose, lets choose
let us choose, let us choose, let us
choose, lets choose let us choose,
let us choose, let us choose,
lets choose let us choose, let us
choose, let us choose, lets choose
let us choose, let us choose let us
choose, lets choose let us choose,
let us choose, let us choose, let us
choose, let us choose, lets choose
let us choose, let us choose, let us
choose, lets choose let us choose,
let us choose, let us choose,
lets choose let us choose, let us
choose let us choose, lets choose

Book of the Dead Bunny
Book of the Begotten

let us choose, let us choose, let us choose, lets choose let us choose, let us choose, let us choose, lets choose let us choose, let us choose.et us choose, let us choose, lets choose let us choose, let us choose, let us choose, lets choose let us choose, let us choose, let us choose, lets choose let us choose, let us choose, let us choose, lets choose let us choose, let us choose let us choose, lets choose let us choose, let us choose, let us choose, lets choose let us choose, let us choose, let us choose, lets choose let us choose, let us choose."

23. Suddenly everybody was chanting: "let us choose, let us choose let us choose, let us choose, let us choose, lets choose let us choose, let us choose, let us choose, lets choose let us choose, let us choose, let us choose, lets choose let us choose, let us choose, let us choose, lets choose let us choose, let us choose, let us choose, lets choose let us choose, let us choose, let us choose, lets choose let us choose, let us choose, let us choose, lets choose let us choose, let us choose, lets choose

let us choose, let us choose, let us choose, lets choose let us choose, let us choose let us choose, lets choose let us choose, let us choose, let us choose, let us choose, lets choose let us choose, let us choose, let us choose, lets choose let us choose us choose, let us choose, lets choose let us choose, let us choose, let us choose, lets choose let us choose, let us choose, lets choose let us choose, let us choose, let us choose, lets choose let us choose, let us choose let us choose, lets choose let us choose, let us choose, let us choose, lets choose let us choose, let us choose, let us choose, lets choose let us choose, , let us choose, lets choose let us choose, let us choose, let us choose, lets choose let us choose, let us choose.et us choose, let us choose, lets choose let us choose, let us choose, let us choose, lets choose let us choose, let us choose, lets choose let us choose, let us choose, let us choose, lets choose let us choose, let us choose let us choose, lets choose let us choose, let us choose, let us choose, lets choose let us choose, let us choose, let us choose, lets choose let us choose, let us choose.et us choose, let us choose, lets choose let us choose,

Book of the Dead Bunny
Book of the Begotten

let us choose, let us choose, lets choose let us choose, let us choose, let us choose, lets choose let us choose, let us choose, let us choose, lets choose let us choose, let us choose let us choose, lets choose let us choose, let us choose, let us choose, lets choose let us choose, let us choose, let us choose, lets choose let us choose, let us choose.et us choose, let us choose, lets choose let us choose, let us choose, let us choose, lets choose let us choose, let us choose, let us choose, lets choose let us choose, let us choose, let us choose, lets choose let us choose, let us choose let us choose, lets choose let us choose, let us choose, let us choose, lets choose let us choose, let us choose, let us choose, lets choose let us choose, let us choose.et us choose, let us choose, lets choose let us choose, let us choose, let us choose, lets choose let us choose, let us choose, let us choose, lets choose let us choose, let us choose, let us choose, lets choose let us choose, let us choose let us choose, lets choose let us choose, let us choose, let us choose, lets choose let us choose, let us choose, let us choose, lets choose let us choose, let us choose.et us choose, let us choose, lets choose let us choose,

let us choose, let us choose, lets choose let us choose, let us choose, let us choose, lets choose let us choose, let us choose, let us choose, lets choose let us choose, let us choose, let us choose, lets choose let us choose, let us choose let us choose, lets choose let us choose, let us choose, let us choose, lets choose let us choose, let us choose, let us choose, lets choose let us choose, let us choose.et us choose, let us choose, lets choose let us choose, let us choose, let us choose, lets choose let us choose, let us choose, let us choose, lets choose let us choose, let us choose, let us choose, lets choose let us choose, let us choose let us choose, lets choose let us choose, let us choose, let us choose, lets choose let us choose, let us choose, let us choose, lets choose let us choose, let us choose..".

24. And Floppsy said: "chose your leader."

Book of the Dead Bunny
Book of the Begotten

7. CHOOSING OF A NEW LEADER

1. Smallballs knew he was going to win as he and his friends have spoken to most the bunnies pointing out the sadness and sorry that Floppsy's rules given to him by "a Great Bunny" was not the way to go.
2. Only a third of the bunnies stood behind Floppsy.
3. Smallballs was overwhelmed with joy and before he could announce the end of the choosing Floppsy turned to the bunnies behind him and asked: "are you sure this is where you want to be?"
4. Some of the bunnies left.
5. Floppsy asked again: "is this what you want to do?"
6. And some more bunnies left.
7. Floppsy asked again: "is this what you believe?"
8. And some more bunnies left.
9. Floppsy had one third of one third standing behind him.
10. Smallballs commanded Floppsy and his followers to Bow down to him.
11. Some of the bunnies behind Floppsy wanted to but Floppsy stopped them.
12. Floppsy told Smallballs that that was not the arrangement. He did not agree to this.
13. Smallballs in another fit of anger lost his temper and commanded his followers to attack Floppsy and his followers.
14. Once those words were spoken Floppsy and his followers were already half way to the edge of the forest that surrounded the plain.
15. Despite the fact that Smallball's followers where younger and stronger, they could not catch Floppsy and his followers.
16. Small balls followers stopped at the edge of the forest.
17. There they all stopped and looked at Smallballs.
18. Smallballs looked at his followers and told them: "don't carry on the creatures in the forest will take care of Floppsy and his followers.
19. I have had negotiations with one of the creatures in the forest. The creature guaranteed my safety, and if I am safe so are all of you.
20. Close to the edge laid KoosBoosDoosLoos, shaking his head.
21. KoosBoosDoosLoos

wondered how silly this was and he went back to his home.

8. SANCTUARY

1. On his way out of the forest he saw a couple of animals watching the crowd of bunnies gathered together so close to the edge.
2. Smallballs called everybody back to the pool and the tree.
3. Once everybody was gathered he spoke to them saying: "do not worry. I have spoken to the leader of the creatures of the forest and he has promised that if we get rid of the one who spoke about the Great Bunny, we will be saved.
4. And we can carry on under my leadership."
5. A sense of calm settled on the bunnies.
6. Smallballs told the group that they may enjoy the evening.
7. He and is partner will be waiting for the unchosen in their room,
8. The room of the leader.
9. Flossy and Floppsy running through the forest became aware as did the rest of their group of the enemy watching them and waiting.
10. They came to the end of the forest and stood waiting for everybody to catch up.

Book of the Dead Bunny
Book of the Begotten

11. Once the group was together they saw all the creatures of the forest, their enemy standing there at the edge of the forest.
12. KoosBoosDoosLoos slithered past the bunnies.
13. He stopped in front of Floppsy and said: "you better come with me…"
14. The bunnies followed KoosBoosDoosLoos without question.
15. Back on the plain there was a big celebration. Smallballs was having the time of his live.
16. All the bunnies ate of the fruit from the Amarula tree and funny things happened as they would when you eat of the Amarula fruit from the ground.
17. Floppsy followed KoosBoosDoosLoos to his home.
18. When they arrived KoosBoosDoosLoos put all to sleep and said they will talk in the morning.
19. And everybody went to sleep.
20. On the plain everybody was drunk with the Amarula fruit and the possibility of new things.
21. Smallballs was in his hole passed out with whoever passed out with him.
22. The bunnies who were still awake were all heading towards their holes.
23. And everybody fell asleep.
24. With the morning light breaking over the plain, all the bunnies gathered at the morning meeting spot for the continuation of the choosing.
25. Smallballs still in his hole waited for a while before joining the bunnies on the plain.
26. Once everybody assembled on the plain Smallballs made the announcement that the choosing was cancelled for the day and it would continue in a couple of days' time.
27. Some of the bunnies were disappointed but did not dare to show their disappointment.
28. The day carried on while most of the bunnies were nursing their headaches.
29. As Floppsy and his followers woke up KoosBoosDoosLoos was lazing in the sun.
30. Floppsy went to KoosBoosDoosLoos and asked him: "thank you for letting us rest here the night. It was very kind of you."
31. KoosBoosDoosLoos opened one eye and said: "don't worry about it, that is what the Great Bunny told me to do.

Book of the Dead Bunny
Book of the Begotten

Anyway, a friend of the Great Bunny is a friend of mine."

32. Floppsy looked at KoosBoosDoosLoos in amazement and asked: "you know the Great Bunny?"

33. KoosBoosDoosLoos closed his one eye and answered: "yes I know the Great Bunny; we are good friends. I also know that he loves you and Flossy very much."

34. All the bunnies heard the conversation and suddenly surrounded KoosBoosDoosLoos with millions of questions being directed to KoosBoosDoosLoos.

35. KoosBoosDoosLoos shouted to get everybody to quiet down, which they did.

36. KoosBoosDoosLoos looked at all the bunnies and said to them: "I have known the Great Bunny for a very long time and I guess so have you. He has told me all about you and the plans he has for you and about the fact that he has to go for a while."

37. Floppsy withouthesitation asked: "you are friends with our beloved Great Bunny?"

38. KoosBoosDoosLoos shook his head.

39. Floppsy continued: "but he has never told us about you, we do not know anything about him except that he loved us, well that is what we think and I am not so sure after yesterday anymore…"

40. KoosBoosDoosLoos shook his head and replied: "don't worry about not knowing about me before, that is what the Great Bunny intended. Furthermore, he warned you about the events of yesterday through a dream he gave to two of you, did he not?"

41. KoosBoosDoosLoos pointing at Cudburry and Brownie and he carried on:

42. "There is a lot you don't know and there is a lot I don't know and that is fine, we do not need to know everything. We only need to know what he wants us to know now."

43. Floppsy carried on: "do you know why he left and where he has gone?"

44. KoosBoosDoosLoos answered: "no I don't. He only told me that he had to go to change into his true form, where this is going to happen I don't know."

45. KoosBoosDoosLoos saw the sad expression on the bunnies' faces and he told them to go and get some food.

46. They were to rest there with him and they would see

what the morning brings.
47. The bunnies left to go and find food and water.
48. They all returned in the late afternoon still hungry. Food was not as available as it was on the plain, but they had enough.

9. ON THE PLAIN

1. On the plain all the bunnies gathered in the late afternoon and waited for Smallballs to make an appearance.
2. He didn't.
3. They all went to their holes to sleep.
4. As some of the bunnies entered their holes, they immediately came out shouting and screaming.
5. Everybody went looking at what was happening.
6. The found the bunnies that went into their holes was lying dead in front of their holes.
7. This lead to great commotion and hysteria.
8. As everybody watched the holes of the dead bunnies not sure what to do.
9. Someone, more precise BigWig asked very loudly: "where is Delta? Why isn't he here to lead us?"
10. This caused a stirring of agreement amongst all the bunnies.
11. Suddenly a bunny shouted that everybody must look at the hole of one of the dead bunnies.
12. Everybody looked at the

Book of the Dead Bunny
Book of the Begotten

hole and was shocked to see a snake slithering out of the hole.
13. All the bunnies ran to their holes but didn't dare to go in.
14. They all feared that a snake was in their hole.
15. They all decided to stay outside.
16. As evening fell and the cool night air started bringing dark clouds over the plain.
17. There was a sudden thud of Thunder, so loud that the bunnies were fearful and when the rain started falling they did not know what to do.
18. Some bunnies thought death would be better than the cold rain and the Thunder.
19. They crawled into their holes and did not find a snake.
20. One bunny shouted to his neighbour that he was safe and there was no snake in his hole.
21. This gave some confidence and all the bunnies carefully ventured into their holes.
22. There were some shouts escaping from a couple of holes, but those that did not find snakes were happy to be alive and did not care about those that died.
23. The next morning as the sun rose all the bunnies that re-mained gathered around the pool waiting for Delta.
24. As the sun reached higher, BigWig eventually told everybody that he would go and have a look where Delta was.
25. BigWig crawled down Delta's hole and as he expected, Delta was in his hole tied, bound and gagged in Cotton's best knots.
26. BigWig quietly laughing told Delta: "you silly, silly bunny. Your arrogance was your weakness and now I will take this from you because it is mine to take Smallballs."
27. Delta was squirming and trying his best to get loos but Cotton was a mistress of the knot.
28. BigWig came out of Smallballs hole with a sad face.
29. All the bunnies looked at him in expectation and BigWig said: "Delta is dead it looks like he was also killed by a snake in his sleep. Let us be glad that our leader did not have to suffer the pain and anguish that the other bunnies suffered."
30. And there was silence.
31. BigWig waited for the silence to carry on long enough.
32. The he said: "in his honour I think we need to close his hole with his body inside."
33. BigWig looked at the bird

Book of the Dead Bunny
Book of the Begotten

setting down around the bodies of the dead bunnies left out in the rain and he continued pointing at the birds feasting on the dead bunny bodies:

34. "I think we all agree that we do not want that to happen to the body of our dearly beloved leader?"

35. There was a quiet agreement.

36. BigWig started filling the hole and was soon joined by other bunnies who lovingly filled the entrance of Delta's hole.

37. After the hole was filled and stamped down one of the younger bunnies asked: "what will happen now? We do not have a leader?"

38. Another asked: "should we go looking for Floppsy and ask him to forgive us and come back to lead us?"

39. Cotton shouted from the back: "no we can't, I heard Delta tell of the agreement he made with the snake, where the snake promised to kill Floppsy."

40. There was panic growing in the murmuring amongst the bunnies.

41. BigWig got tired of waiting for someone to make a suggestion and said to the gathered bunnies:

42. "I have been here as long as anybody else, I have in my arrogance tried to challenge Floppsy and got beaten.

43. I have learned from my arrogance and I have observed all the rules that we have been given in humility."

44. Before BigWig could carry on Cotton interrupted: "my bunny, before you carry on I know you were going to suggest someone to take leadership of us, but before you name the bunny I would like to propose you as our new leader.

45. You have learned from your mistakes, even my grandfather noticed.

46. He was impressed and even mentioned in passing that you will one day make a great leader."

47. Cotton turned to the rest of the bunnies and carried on: "with my grandfather's words as my guide would you consider BigWig as our new leader?"

48. The bunnies murmured amongst themselves for a while and then each of them agreed that if that was the words of Floppsy then they would agree.

49. And BigWig became the new leader.

50. Delta heard the words

spoken in his hole and struggled to get loose and out but he lost consciousness.

51. Once BigWig was acknowledged as the new leader, he stood in front of the bunnies and said that he would go back to the ways of Floppsy.

52. All the bunnies were happy.

53. He continued saying that they would take a day of rest to commemorate the day Floppsy and his people left as well as the day that their leader Delta passed away.

54. All the bunnies were happy and went out eating.

10. OUTSIDE THE PLAIN

1. Outside the plain all the bunnies once all the bunnies returned from finding food, KoosBoosDoosLoos called them all together and said: "you may rest here another night, but tomorrow you have to go and find a new home."

2. Floppsy stood up and thanked KoosBoosDoosLoos for his kindness and told the bunnies to go and rest as tomorrow would be a long day.

3. Once all the bunnies were asleep Floppsy went to wake Cudburry and they went to meet with KoosBoosDoosLoos.

4. The three met away from the sleeping bunnies.

5. Once gathered together Floppsy started by asking KoosBoosDoosLoos: "dear KoosBoosDoosLoos, do you know what the way is we should go tomorrow?"

6. KoosBoosDoosLoos looked at the two bunnies and answered: "no, the Great Bunny has only shown me the way until yesterday, today was done because I do not know what is laying ahead."

7. The bunnies were quiet, thinking.

Book of the Dead Bunny
Book of the Begotten

8. Floppsy spoke: "so the Great Bunny has not shown you anything else?"
9. KoosBoosDoosLoos shook his head.
10. Cudburry spoke and asked: "KoosBoosDoosLoos have the Great Bunny ever mentioned the Great Dead Bunny."
11. And there was silence.
12. KoosBoosDoosLoos answered: "the Great Bunny has spoken about a change coming and the great dead bunny, I was never sure what he meant and I don't think it is my place to find out what he meant, why do you ask?"
13. Floppsy told Cudburry to tell KoosBoosDoosLoos of the dream.
14. KoosBoosDoosLoos looked at Cudburry wondering if he really wanted to know about the dream.
15. But Cudburry told KoosBoosDoosLoos and KoosBoosDoosLoos listened.
16. After Cudburry told KoosBoosDoosLoos about the dream, KoosBoosDoosLoos thought for a bit.
17. KoosBoosDoosLoos then asked: "is it really our place to ask? Has the Great Bunny not shown us what we needed to know when the time was right for us to know?
18. Everybody thought about this for a while and Floppsy eventually said: "yes he has and so we need to obey his words without question. "
19. So there was an agreement.
20. And Floppsy asked KoosBoosDoosLoos: "based on the trust the Great Bunny has shown in you, what would you suggest as the way we should travel tomorrow?"
21. KoosBoosDoosLoos thought about the answer for a bit and then replied: "I am not sure but the humans went south and I know they are not happy so maybe going to the north would be better."
22. And it was agreed that the north would be a better option as everybody remembered how problematic the humans were.
23. Everybody went to sleep.
24. The next morning when all the bunnies awoke Floppsy called them all together and told them that they will be moving to the north.
25. And everybody needed to eat early in the morning so they could travel.

26. As the bunnies were Scrounging for food Floppsy went to KoosBoosDoosLoos and said: "dear KoosBoosDoosLoos, we cannot thank you enough you have been a great friend to us in the name of the Great Bunny, I know we all owe you a great debt, so thank you."
27. KoosBoosDoosLoos did not know how to rely and simply said: "you are a friend of my beloved Great Bunny and so a beloved friend of me, I trust that the Great Bunny would see you though the days ahead. Now go."
28. And the bunnies left to the north.

11. BACK ON THE PLAIN

1. As the sun rose on the plain, several bunnies came out of their holes to find a strange new world awaiting them.
2. What nobody knew was the going on during the night.
3. When BigWig got to his hole, his beloved wife waited for him.
4. Cotton greeted BigWig and invited him in to their home with food already gathered.
5. They ate quietly and eventually BigWig was getting nervous.
6. Cotton was never this quiet and as pleasant as she was on that night, unless there was something wrong.
7. BigWig ventured a question: "are you happy my dear?"
8. Cotton ate quietly and glanced over at BigWig and smiled.
9. BigWig said: "my dear, I have to thank you, I got a bit derailed from our original plan but you made it work as only you can. I thank you for your quick thinking."
10. Cotton still quietly eating smiled at BigWig without a word.

Book of the Dead Bunny
Book of the Begotten

11. BigWig unsure of how to proceed just kept quiet and finished his food.
12. He proceeded to stand in the desired position for Cotton to abuse him and he waited.
13. Nothing happened and BigWig was disappointed.
14. Cotton was already asleep when I looked to see why nothing was happening.
15. He went to sleep wondering what was waiting for him.
16. The next morning BigWig was up early and left Cotton sleeping as he went to go and greet the other bunnies.
17. BigWig greeted everybody at the pool.
18. And there was joy amongst the bunnies with the regained stability.
19. But there were fewer of the bunnies – BigWig sent the gathered bunnies to go and look for the missing bunnies.
20. All the bunnies went to the holes from where their friends and family never came.
21. Inside the holes the dead bodies of their friends and family were found.
22. Some looking like they were still in a peaceful sleep and others found their loved ones in heaps of blood, fur and whatever was left over.
23. All the bunnies returned to BigWig with their tales of sorrow, grief and anguish.
24. BigWig stood in front of all the bunnies not sure what to make of the chaotic stories that flooded his ears and his mind.
25. After a couple of minutes of cacophony, he shouted for everyone to be quiet.
26. Everybody went silent.

Book of the Dead Bunny
Book of the Begotten

27. BigWig gathered his thoughts.
28. He said: "everybody, we are probably being punished for the wrong we have done to Floppsy and the bunnies that

died with him.

29. Let us all mourn those that have gone and ask the Great Bunny to forgive us. So we may carry on with his way of life. But if there are more lives to be taken, let it be those that deserve it."

30. The group of bunnies was driven with guilt and sorrow for what they have done and the cacophony broke out again.

31. BigWig quieted everybody again and said to them: "please let us all calm down. This is not a time for chaos to rule, we have done wrong and we have to pay the price.

32. So please let us all mourn the departed and spend the day in quiet to get our minds focused on the truth that the Great Bunny has taught Floppsy and Flossy. Please now go and find quiet."

33. As the bunnies was about to leave the morning greeting time, the fear they all shared for themselves started rising amounts their numbers.

34. A voice spoke out: "do not be fearful of what has happened to you, it is a necessary event and it will continue."

35. The bunnies looked around for the speaker of the words, but found no-one.

36. BigWig in particular was looking for the bunny that spoke those words.

37. BigWig said to the bunnies surrounding him: "who thinks this is funny?

38. Who spoke those words to us? You shall be the one who died today mongering fear amongst us that loves the Great Bunny as Floppsy and Flossy did. Tell us who you are and your death will be fast."

39. The voice answered from all the mouths of the bunnies that surrounded BigWig: "Floppsy and Flossy will know my voice, as they are still alive with all those that chose me.

40. BigWig I know you and the falseness of your words.

41. You will not die as it is not necessary for you and your beloved Cotton to die yet.

42. You will be the one to tell Floppsy and Flossy of this event, the sacrifice of those I love before you die."

43. BigWig was pale with shock.

44. The voice continued: "yes, it is me the Great Bunny you funny bunny.

45. I need the lives of most of you to complete the transformation of what is yet to come, but don't worry there is no

punishment or reward waiting for you.
46. That is reserved for the others that will come after you."
47. All the bunnies hearing the voice come from everybody's mouths were shocked.
48. All the bunnies not sure of how to continue or give comment went their ways to go and be quiet.
49. And the sacrifice truly started.

www.ingramcontent.com/pod-product-compliance
Lightning Source LLC
Chambersburg PA
CBHW061442180526
45170CB00004B/1518